PRINT'S BEST LETTERHEADS & BUSINESS CARDS 6

*PRINT's Best Letterheads &
Business Cards 6*
Library of Congress Catalog
Card Number
89-091067
ISBN 1-883915-10-4

RC Publications
President and Publisher:
Howard Cadel
Vice President and Editor:
Martin Fox
Creative Director:
Andrew P. Kner
Associate Art Director:
Michele L. Trombley
Associate Editor:
Katherine Nelson
Assistant Editor:
Robert H. Treadway III

Writer/Editor
Caitlin Dover
Art Director
Andrew P. Kner
Project Supervisor
Katherine Nelson
Assistant Editor
Robert H. Treadway III
Art Assistant
Charisse Gibilisco

Winning Designs from
Print *Magazine's*
National Design Competition

PRINT'S
BEST
LETTERHEADS
& BUSINESS
CARDS

6

*I*ntroduction

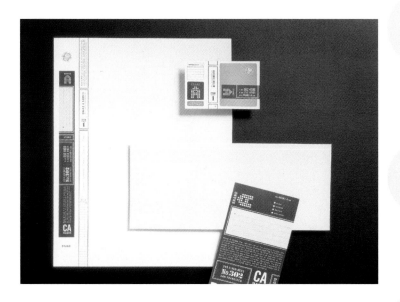

Getting mail has good connotations. As long as the envelope doesn't contain a request for money (or a facetious promise thereof), chances are that incoming letters will be welcomed. It seems safe to say, however, that the designers in this year's *Best Letterheads & Business Cards*, selected from recent editions of PRINT's Regional Design Annual, are even happier about sending mail than receiving it. At least that's what can be surmised from this edition's large selection of design firms' self-promotional letterheads. Let's assume that more designers than ever are pleased with their letterheads and business cards and they want the world to know it.

 This proliferation of designer stationery has been helpful in highlighting what appears to be a trend in letterhead design. The trend could be seen as twofold: One, we are seeing far fewer of the multi-component systems that previously held sway; more often than not, the stationery consists of no more than the basics: letterhead, envelope, business card. Two, while the trend is especially evident in design firms' stationery, it is also apparent in most of the other sections of this book. A good tag for it might be "Kindergarten Cool," for one gets the feeling that designers who worked in this vein were harking back to the elementary art class of their school days. That was when art was simple and fun, and the only thing inhibiting creativity was a lack of rubber cement. Stickers, rubber-stamps, punched holes and the inventive folding of paper are all features of this genre, and, used properly, they have the effect of transforming run-of-the-mill stationery into something verging on entertainment.

 What does this approach have to do with more limited stationery systems? Well, maybe designers are thinking that just a little playful ingenuity not only goes a long way, but also saves money. Rather than adding more paper to the stationery package, why not explore more fully the possibilities of the paper you already have?

 Exhibit A for this take on stationery is, appropriately enough, a studio called Brand A. Their system consists of envelopes, letterhead and cards, and is enhanced by a set of stickers bearing the firm's address,

phone number and other vital info. An embossed *A* and perforation on the card adds to the effect. "The addition of multiple tactile elements encourages physical interaction from the recipients. It's the closest we've come to creating an interactive business card," says art director Guthrie Dolin. "The concept was to create an inexpensive and flexible business system that reflected the studio's design esthetic and sense of humor."

Stickers seem to be a popular method of conveying a firm's ethos to the world at large. Carmichael Lynch Thorburn employed a variety of self-designed, iconic stickers to add a visual element to their heavy, brown paper cards and envelopes and their newsprint letterhead. Explains designer Chad Hagen, "A business system was needed that reflected the attitude and culture of the company. The solution was to create a system that could be customized for the client/potential client receiving the materials. We created a group of stickers representing the values of the company that could be applied in any combination on the system's pieces." Thus, depending on the client's bent, a designer might add a sticker bearing the word "faithful" over a drawing of a dachshund; or an orange and white flame illustrating the word "cool." Punched holes in the corners of the cards complete the "I-made-it-myself" feeling that the system exudes in spades.

For some design studios, this homemade esthetic sprang from the need to accommodate flux. Anabliss Graphic Design was planning to move when they printed up their stationery, so, to cut costs, they did not print their address or phone number on the paper or cards. Instead, they set their laser printer to place this information on the bottom of every letter. For the business cards, they made rubber stamps that were applied to the cards' backs. As Anabliss's owner, Matt Coffman, says, "We saved not only by printing on one side, but also by not having to reprint the stationery when we moved."

Malcolm McGaughy of McGaughy Design also turned to rubber-stamping as a cheap, attractive way

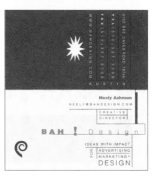

to bridge a gap. He designed the stationery that appears here to replace his former system, which didn't carry his fax number or e-mail address. "Since I didn't know how long it would take to come up with a logo I liked, I decided to create a temporary set," he says. To get across the notion of an "identity under construction," he used mismatching paper for the letterhead and envelopes and plain brown cardboard for the cards. He used the stamps to apply both his tagline—"Pardon Our Dust. McGaughy Design is Undergoing Renovation"—and his contact information to the system. "The cost was minimal," he reports. "The stationery was cheap and the rubber stamps ran about $25." Proving that big bucks aren't always necessary to make a successful design, the stationery has elicited positive responses from many of those who receive it. People have even urged McGaughy to keep the design as a permanent look.

The above-mentioned designers breathed new life into time-honored methods of affixing and applying designs to paper. Others in this book manipulated the paper itself into designs that are surprisingly simple —and simply surprising. We might divide this "paper people" category into two camps: the folders and the punchers. The former is exemplified by Brian De Los Santos and Clark Hook, both of whom employed a toned-down version of pop-up book tactics. De Los Santos devised for his client, actor Stephen Garris, a business card that gives him a face-lift of sorts: flip open the card, and the actor's face goes from a frown to a smile. Hook's stationery for a furniture maker conjures a chair out of thin air (or at least, thin paper), giving the client's logo an instant 3-D treatment via two cuts and a fold.

BAH! Design also depended on a cut and a fold, though with markedly different results. The front of their folded card bears a woodcut-style image of two rams, heads colliding. A starburst cutout emphasizes the point of contact, framing a red exclamation point—much as one would find in the comics. Open the card, and

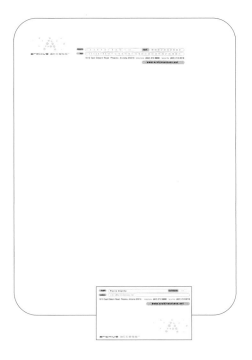

you see that the punctuation mark is a component of the design firm's name, and that the visual on the front illustrates their motto: "Ideas with impact for marketing and design."

Designers aren't the only ones who can wow their customers with cutouts. CFD Design uses laser-cut holes to fine effect for their client Archive Access, a digital storage and data-transfer company. The holes, which spell out the initial *A*, work on the stationery's front as an element in the company's logotype, and also show through the paper's silver-metallic, ink-flooded back. Bubble-like and loose, the holes remind the viewer of the rounded shape of mercury beads, and convey a sense of 21st-century sleekness.

Unfortunately, all this creative use of paper, enjoyable as it may be for designer and recipient alike, can have an unpleasant side effect, namely, the disapproval of one's printer. Neely Ashmun, creative director at BAH! Design, says that they had to "go against our usual habit of following the advice of our printer on this job. He kept telling us that some part of the design would print badly and that we should increase line width on type that reversed out of solids and eliminate other elements. We finally had to put our foot down and take the chance that our instinct was right."

Nestor Stermole's stationery, every piece of which boasts their initials spelled out in tiny, die-cut holes, also soured relations with their printer, due to an unfortunate circumstance. Creative director Rick Stermole recalls, "In the first production run the die was very fragile and had to be rebuilt a number of times. This run was being produced at a printer in Atlanta, during the Olympics, which delayed production for months. The printer will never speak to us again." Luckily for the design firm, they came out of this unpleasant situation with something to show for their pains: While their printer may no longer be their pal, we imagine that their stationery is making them quite a few new friends. —*Caitlin Dover*

CONTENTS

*R*etail. *P*roducts. *M*anufacturers.

Whether creating stationery for a retail store or a manufacturer, the designers in this section seem to have a shared agenda: emulate the product. While no one went as far as actually printing on a slab of wood, or attempting to cut envelopes in the shape of a teacup, many did their best to incorporate aspects of their clients' products into the stationery.

First among equals in this approach to retail letterheads is Lewis Communications. Its work for Nellie's Originals, makers of heirloom-quality children's clothing, and for Jim Profitt, a manufacturer of wood furniture, uses paper in unconventional ways to communicate key information about the clients. For Nellie's Originals, the firm avoided the necessity of printing up separate letterhead by simply attaching the business cards to the stationery paper. A row of stitching (courtesy of the client) holds the business cards to the top edges of the paper, and also decorates the cards that are not so attached. The white thread across the delicately patterned, fabric-like paper gives the stationery an unusual twist, as well as serving a purpose.

The firm's design for Jim Profitt is equally inventive. Clark Hook, designer and art director for the project, says the biggest challenge he faced was "how to give a small, independent furniture maker with limited resources a big impact." Choosing to emphasize on the stationery the hand-crafted nature of his client's products, Hook used pencil sketches and hand lettering on a natural-colored, fibrous paper. His stroke of inspiration, however, was to include a tiny, pop-up chair on the top and bottom margins of the stationery and in the folded business cards. Unfold the paper, and the square notch at the top edge is transformed into a simple, straight-backed chair, rendered in pencil. Hook's solution cost little, and took full advantage of the materials at hand.

Lisa Fargo, who designed the stationery for Heather George Pottery, might not have opted to have earthenware springing from her envelopes, but, like Hook, she did try to convey the one-of-a-kind nature of her client's products. "The client wanted the stationery to have a handmade, earthy look, to tie in to the style of the studio," she states. Recycled and flecked paper stock and a "torn" edge gave the stationery package the appropriate feel. As for a visual device, the designer chose the loose look of the sketches used by the potter to plan her pieces.

It's a plus to be able to alert your client's customers, via stationery, to the fact that their product is well-made, beautifully designed and original. If you can also evoke a long and proud tradition of craftsmanship and customer satisfaction, all the better. The designers at Hornall Anderson Design Works, who were responsible for creating a new logo and letterhead for U.S. Cigar, settled on a logotype "reminiscent of a cigar band as well as the contour of an old ashtray." According to the design team, the stationery was fashioned after "retro-style forms, ledgers, and manifests, and reflects tobacco shipping ledgers from turn-of-the-century schooners." Deep Design also looked to the past for inspiration in devising the letterhead for Dr. Michael Smith's Veterinary Collectibles. Of course, their client actually deals in the past: The company sells veterinary antiques from the 1850s to the 1930s. Deep Design's logotype for this unusual business emulates the engraved look common in 19th-century letterheads, employing actual period engravings to achieve the desired effect. Also, the stationery paper itself was given the yellowed and stained appearance of age—the designers scanned a 115-year-old document for its discoloration. Apparently, this last measure was misinterpreted by the printer, who thought the splotches and tones were a mistake and tried to correct them. These are the perils the designer faces when challenging the norms of letterhead design.

Stationery for a contract furniture company.

Design Firm:
Square One Design
Grand Rapids, MI
Principal:
Lin Ver Meulen
Creative Director:
Lin Ver Muelen
Designer:
Yolanda Gonzalez
Illustrator:
Yolanda Gonzalez

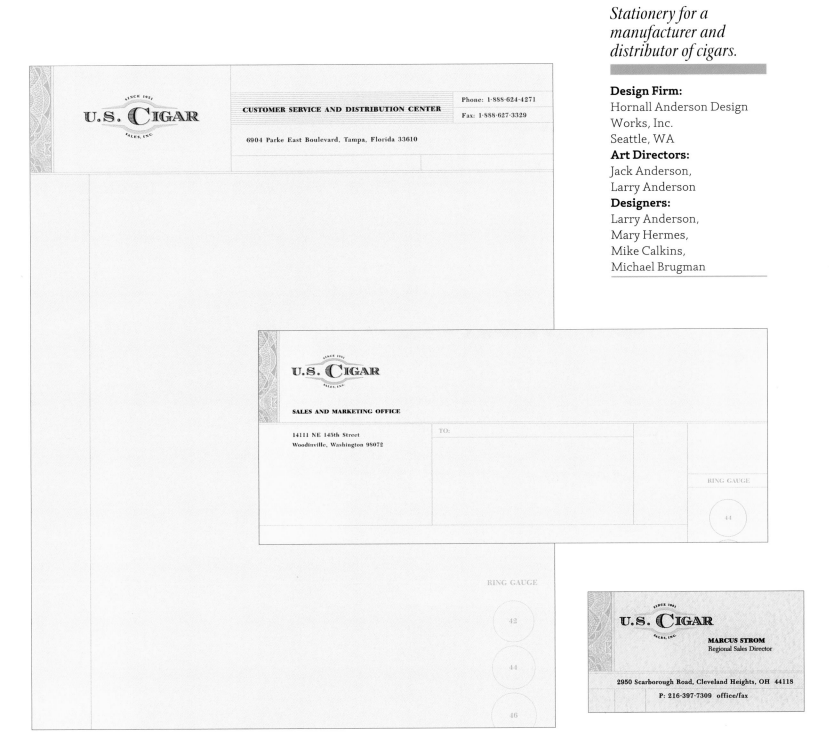

Stationery for a manufacturer and distributor of cigars.

Design Firm:
Hornall Anderson Design
Works, Inc.
Seattle, WA
Art Directors:
Jack Anderson,
Larry Anderson
Designers:
Larry Anderson,
Mary Hermes,
Mike Calkins,
Michael Brugman

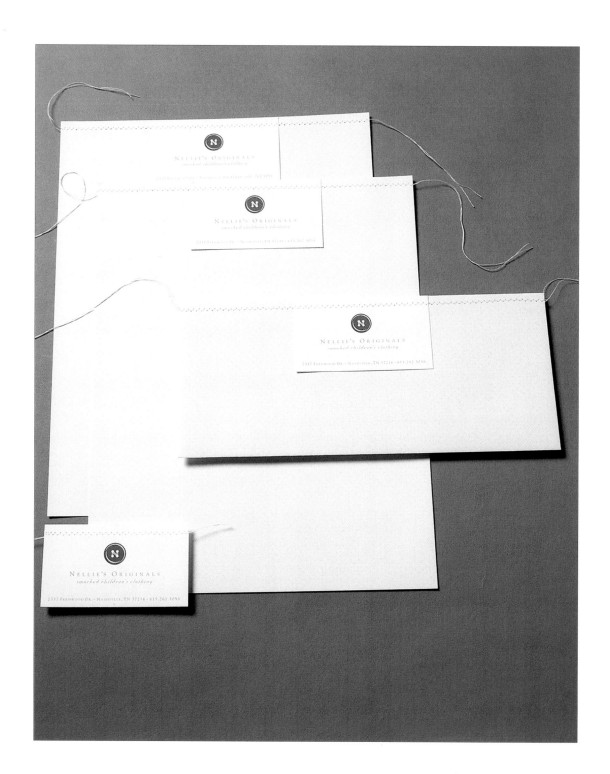

Stationery for a maker of smocked children's clothing such as baptism gowns and Easter dresses.

Design Firm:
Lewis Communications
Brentwood, TN
Designer:
Robert Froedge

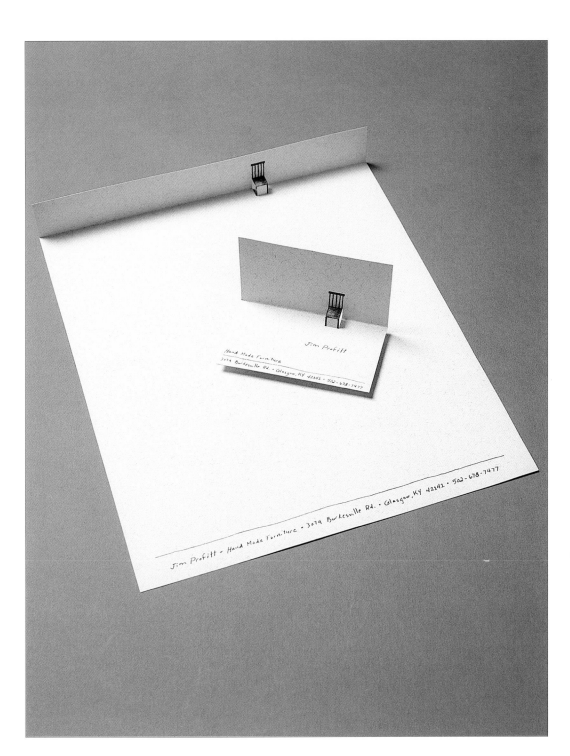

Stationery for a manufacturer of wood furniture.

Design Firm:
Lewis Communications
Nashville, TN
Art Director:
Clark Hook
Creative Director:
Cindy Sargent
Designer:
Clark Hook
Illustrator:
Clark Hook

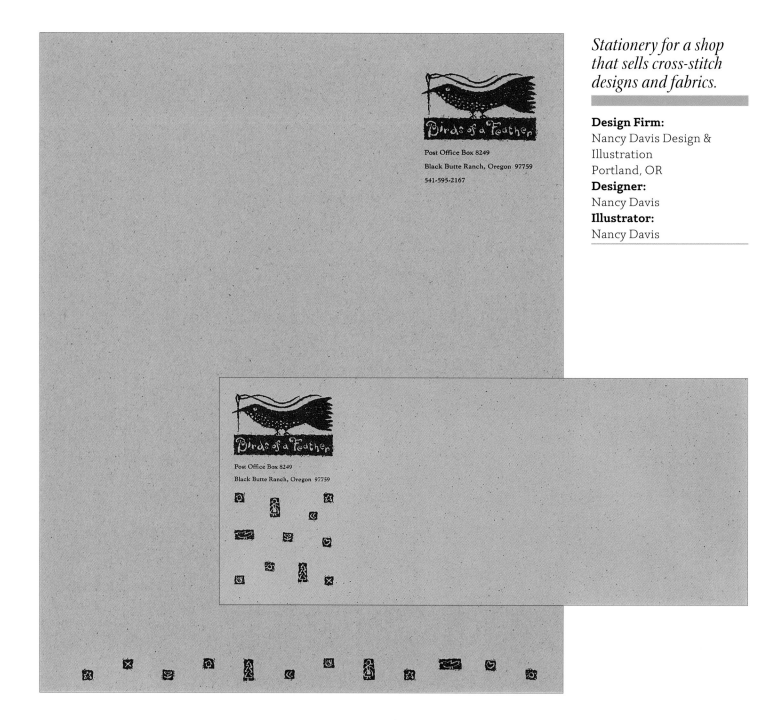

Stationery for a shop that sells cross-stitch designs and fabrics.

Design Firm:
Nancy Davis Design & Illustration
Portland, OR
Designer:
Nancy Davis
Illustrator:
Nancy Davis

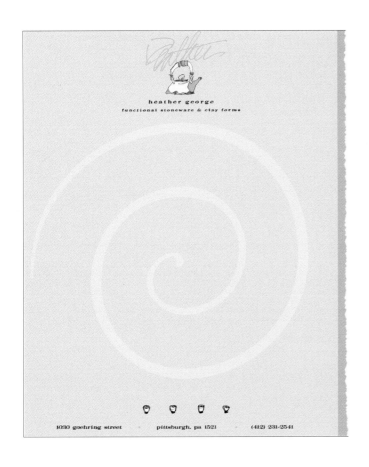

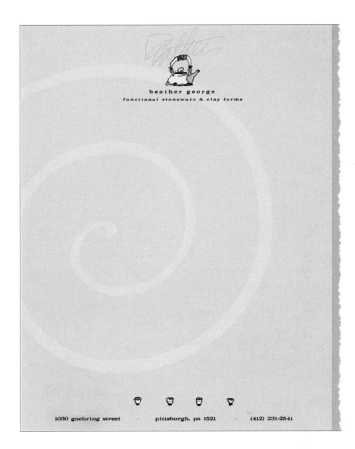

Stationery for a pottery studio.

Designer:
Lisa Fargo
Pittsburgh, PA
Agency:
Jack Horner
Communications

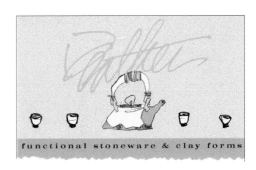

Stationery for a mail-order business that sells vintage veterinary antiques.

Design Firm:
Deep Design
Atlanta, GA
Art Director:
Edward Jett
Designer:
Philip Shore
Production:
Heath Beeferman

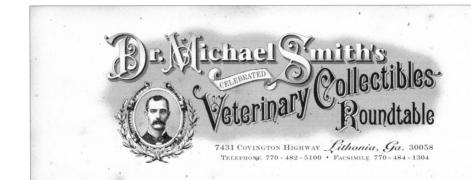

Stationery for a restaurant.

Design Firm:
Riley & Company
Fort Wayne, IN
Designers:
Bob Kiel,
Audrey Riley
Illustrator:
Bob Kiel

Steaks. Cocktails. Ring-a-ding-ding.

PO BOX 11511
FORT WAYNE, INDIANA 46858

Steaks. Cocktails. Ring-a-ding-ding.

235 EAST SUPERIOR STREET • FORT WAYNE, INDIANA 46802 • PO BOX 11511 • FORT WAYNE, INDIANA 46858
TOLL FREE 877.CLUBSODA • VOICE 219.426.3442 • FAX 219.426.4214

GEARHEADS BIKE SHOP

Stationery for a bike shop.

Design Firm:
Rader Design
Indianapolis, IN
Art Director:
Duane Rader
Illustrator:
Steve Beard

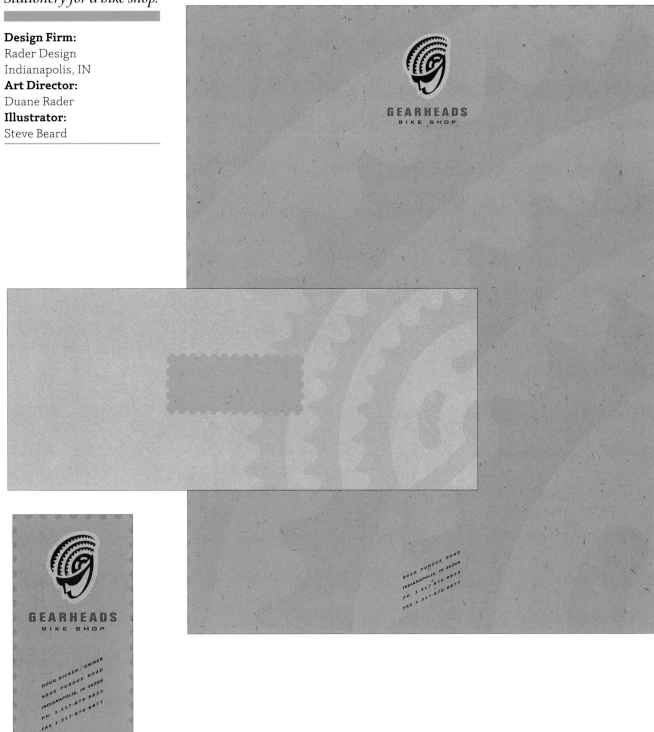

Technology

This section offers a supreme irony: Most of the companies here exist and conduct their business solely on the Internet, yet all of them required letterheads, envelopes and business cards for correspondence. This seems as good a sign as any that, contrary to some predictions, the print and digital worlds will coexist for some time to come.

In fact, when it comes to producing letterheads, it looks as if the digital realm is having a positive effect on print work. Internet companies understand that new technology needs a new look, and they are often ready to take risks with design. Some companies even encourage designers to push the limits of their own work. Art director Paul Black of Squires & Company states that their client, I-Think, actually rejected some preliminary designs as being too conservative. Black welcomed the challenge I-Think offered. "The client was great to work with. Her standards were high, and she wanted a different approach for her company," he reports.

"Different," "up-to-date," "cutting-edge"—these are qualifiers many high-tech businesses used in describing what they wanted in their letterheads. Brian Adducci, who did the letterhead for Aisle Five, an Internet marketing agency, says his design had to convey the following traits: "fast, innovative, unbounded, strong, playful, cutting-edge, aggressive, and memorable—with an attitude." With client requirements like that, designers might feel that they were being asked to brand a space shuttle or a presidential candidate rather than an Internet company. Luckily, dot-com businesses vary just as "real" ones do. For Alibris, an on-line retailer of rare books, the designers at Pentagram wanted to suggest "the hand-crafted or special art" quality inherent in limited-edition and rare books. The resulting letterhead does convey these traditional values, but it also hints at the tech-y with its sleek, almost abstract look. It's definitely up-to-date, but it offers a link (no pun intended) to the not-so-distant past.

The sale of rare books is a relatively simple concept to get across. But one of the larger problems facing designers of letterheads for cyber businesses is the lack of an easily grasped idea. Take the case of the CrystalGate Corporation, a software development company specializing in Web-based customer contact. Designer Val Paul Taylor describes the brief: "CrystalGate implies a gateway to Web communications. The problem was to create a mark that showed the gate as well as the movement of ideas and voice in a Web-based world." Taylor's design employed the image of a gate, both in the logo and on the white stationery, which he crossed with a cream-colored arc. He says the company's response to the letterhead was euphoric: "When you have a whole room full of non-visual software engineers cheering, you know you've touched a nerve."

The tech-heads in general seem to have received their new letterheads gratefully; even the forward-thinking ones at Aisle Five discovered that nothing works better than a good stationery system. According to Adducci, employees of the company were seen using their (120-lb. cover) business cards as windshield scrapers during the cold Minnesota winter. Further proof that print is far from obsolete.

Stationery for a Web-based company that brings together rare-book collectors and book dealers.

Design Firm:
Pentagram Design Inc.
San Francisco, CA
Art Director:
Kit Hinrichs
Designers:
Jackie Foshang,
Anita Luu

Alibris

Data Center

377 Main Street

Greenfield, MA 01301

Telephone 413.774.2640

Fax 413.774.2551

Alibris

Data Center

377 Main Street

Greenfield, MA 01301

Alibris

Data Center

David C...

Technical Support Manager 377 Main Street

Greenfield, MA 01301

Telephone 413.774.2640

Fax 413.774.2551

davidc@alibris.com

www.alibris.com

Stationery for an educational children's Web/TV company.

Design Firm:
Big Blue Dot
Watertown, MA
Art Director:
Tom Corey
Designer:
Tim Nihoff

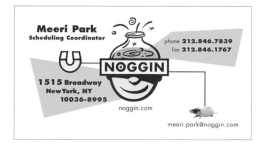

Stationery for a company that conducts Internet consumer research.

Design Firm:
Squires & Company
Dallas, TX
Art Directors:
Paul Black,
Clark Bystrom
Creative Director:
Paul Black
Designer:
Clark Bystrom

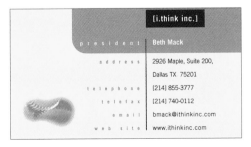

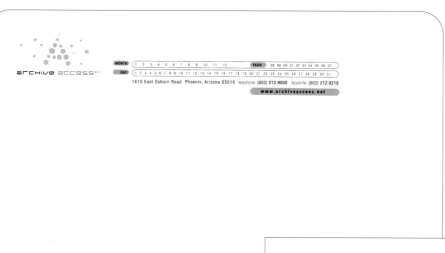

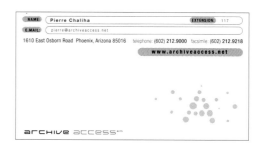

Stationery for a digital asset management company.

Design Firm:
CFD Design
Phoenix, AZ
Art Director:
Mike Campbell
Designer:
Mike Tomko

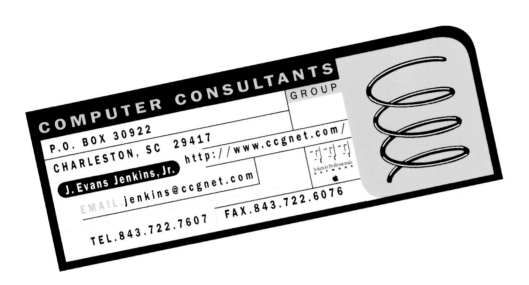

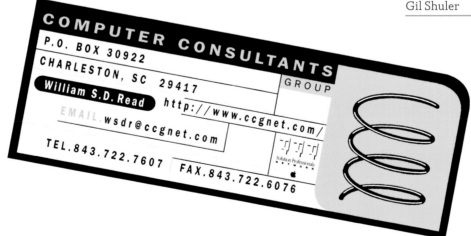

Business card for a company offering generic computer consultation on system configuration, Internet access and trouble-shooting.

Design Firm:
Gil Shuler Graphic Design
Charleston, SC
Art Director:
Gil Shuler
Designer:
Gil Shuler

Stationery for an Internet real-time marketing agency.

Design Firm:
Yamamoto Moss
Minneapolis, MN
Art Director:
Brian Adducci
Designer:
Brian Adducci

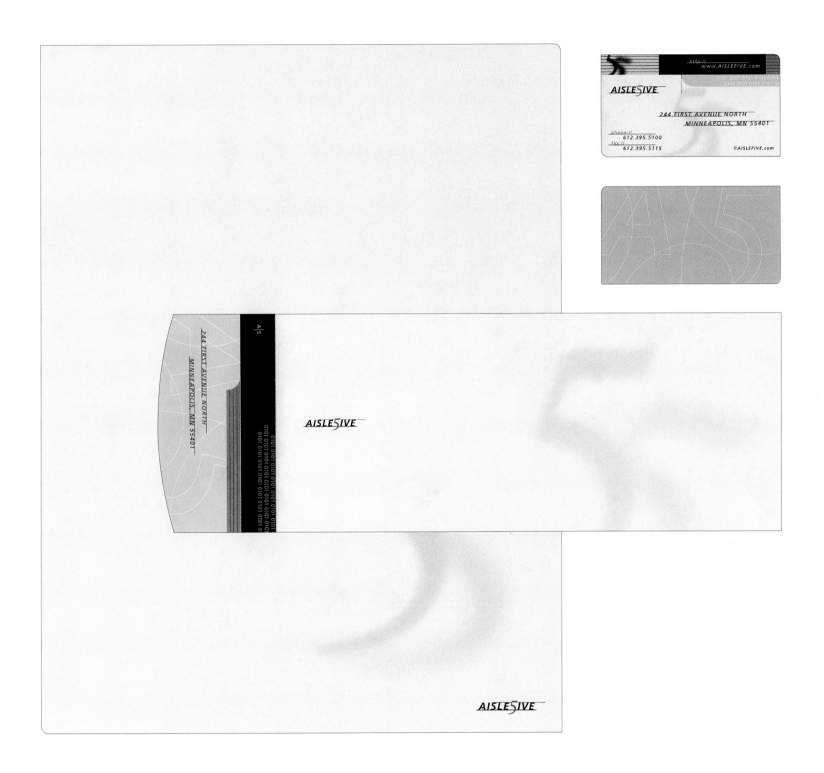

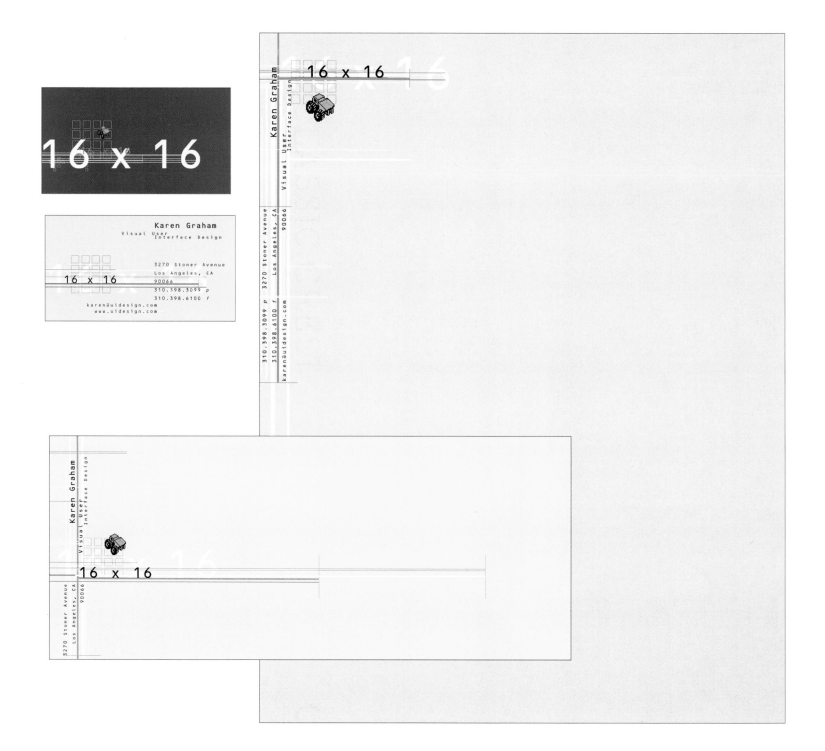

*Stationery for a visual
interface designer.*

Design Firm:
5D Studio
Malibu, CA
Art Director:
Jane Kobayashi
Designer:
Victor Corpuz
Photographer:
Karen Graham

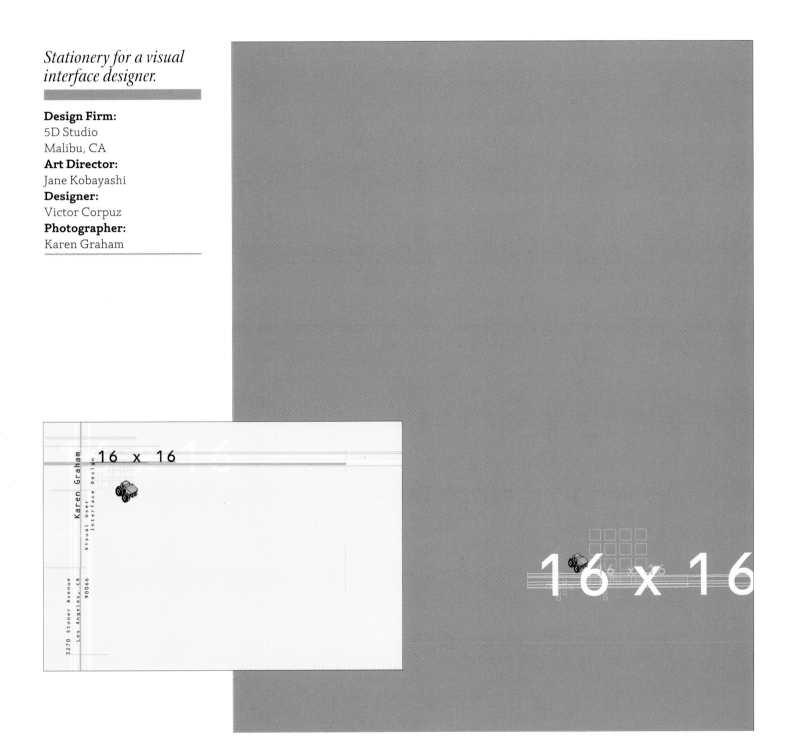

IMAGETEK

Before

After

Stationery for a digital archiving/information retrieval company.

Design Firm:
Sayles Graphic Design
Des Moines, IA
Art Director:
John Sayles
Illustrator:
John Sayles

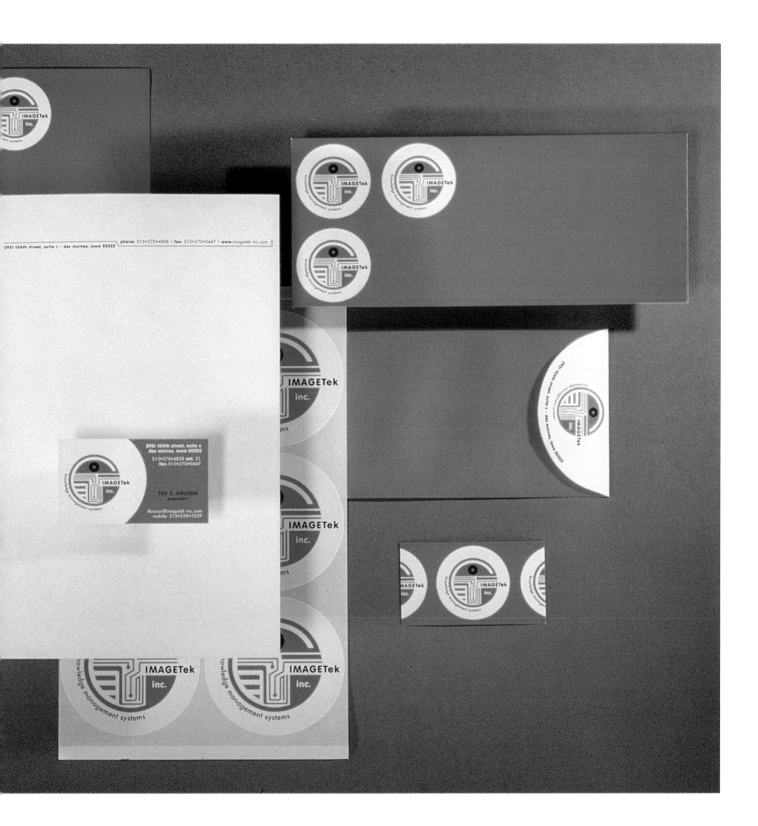

COLLECTING EVERYTHING

Stationery for an on-line company that retails collectibles.

Design Firm:
Supon Design Group
Washington, DC
Art Director:
Supon Phornirunlit
Designer:
Pum Mek-Aroonreung
Illustrator:
Pum Mek-Aroonreung

SUPON PHORNIRUNLIT · 1523 P STREET, NW · WASHINGTON, DC 20005

SUPON PHORNIRUNLIT · 1523 P STREET, NW · WASHINGTON, DC 20005

SUPON PHORNIRUNLIT · 1523 P STREET, NW · WASHINGTON, DC 20005

SUPON PHORNIRUNLIT · 1523 P STREET, NW · WASHINGTON, DC 20005

Stationery for a company that develops software for Web-based, real-time customer contact and human services.

Design Firm:
Val Paul Taylor Design
Seattle, WA
Designer:
Val Paul Taylor
Illustrator:
Val Paul Taylor
Production:
Joseph Crisafulli
Marketing Director:
Linda Hobaugh

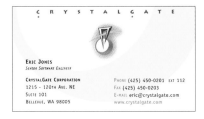

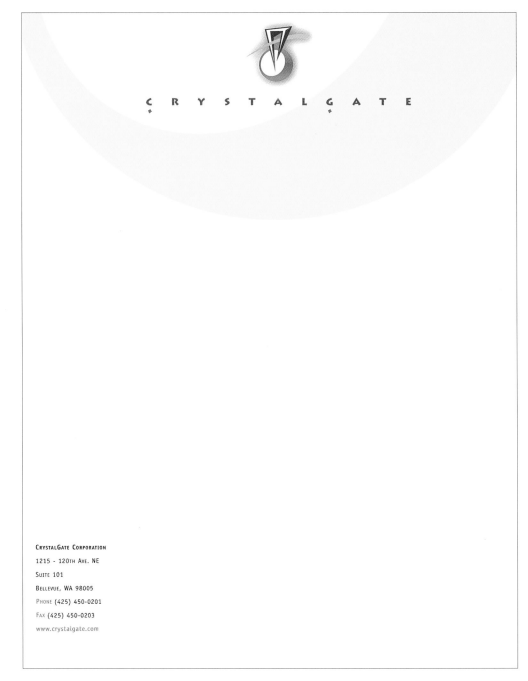

Creative Services

Graphic designers are accustomed to working with clients who aren't "visual" people; who have no feeling for design. Occasionally, however, the client's business is producing pictures, buildings and spaces. In this section we have an unprecedented number of architects and photographers, not to mention writers, interior designers, and even a bona fide artist. Clients like these can offer a new angle on a design project, either through their input or by the nature of their work. Ideally, this kind of assignment can end up being a partnership, with the designer's work complementing the client's.

This ideal certainly transpired for Pensaré Design Group, which designed the stationery for self-taught artist Joe Light. The creative director on the project, Mary Ellen Vehlow, owns some of the client's artwork, and it was, no doubt, her admiration for this work that prompted the firm to donate its services. (According to the designers, the stationery that appears here replaces "the handwritten address and phone number on a torn-off sheet of notebook paper.") Taking their inspiration from Light, who paints on found materials, the designers chose a rough, recycled paper for the stationery. They then rubber-stamped the art—scans of the client's work and signature. Definitely a case of creativity feeding off creativity.

This kind of symbiotic relationship between artists and designers can work in other ways as well. A couple of design firms in this section recognized their clients' creative proclivities and thoughtfully put together stationery packages that required some assembly. For photographer Steve Belkowitz, designer Laurie DeMartino produced a sheet of perforated stickers, some carrying the photographer's images, and some bearing his telephone number, firm name and address. This gave the photographer the opportunity to choose which visuals he wished to appear on any given piece of correspondence, and allowed him to play with layout if he chose. Art director Tim Walker settled on a similar approach for his client, Robert Sharp, Architect. "They wanted a very flexible system that could be applied to all business communication, both internal and external," he states. "The solution was built around a set of crack-and-peel labels that are used on every piece of the system including business cards, letterhead, and envelopes." To further personalize the system, all of the firm's architects provided an icon-style architectural rendering for use on their own business cards, with the founder's icon as the base image on the remaining pieces. The handmade look of the firm's stationery has gone over well with its clients, who often comment that "it adds an immediate personal touch to the client/architect relationship." The stationery has also had an interesting benefit for the firm's employees: They have embraced the DIY-aspect of the new system, thoroughly enjoying the "assembly parties" which the labels make expedient. It looks as if Walker's design has given workplace bonding a whole new meaning.

On the subject of bonds, it's not unusual for a design firm and its creative client to share an esthetic sensibility. One of the designers here shares blood—with his brother (and client), photographer Bruce Nelson-Fernandez. Bryant Fernandez designed his sibling's first identity system, as well as the current one that replaced it. He decided against using images of photographic equipment, focusing instead on the photographer's visual skills by spelling out his name in the pattern of an eye chart. As the designer states, "[In an eye test] the ability to read all the lines as quickly and accurately as possible is the goal. A photographer is presented with the same test every time he or she is on a shoot." Not surprisingly, his client let Fernandez do more or less as he pleased with the project. "There was a great deal of trust," says the designer.

Stationery for an interior and architectural design firm.

Design Firm:
Paper Scissors Stone Inc.
Seattle, WA
Designers:
Scott Cameron,
Lisa Ewing
Illustrator:
Chris Carlson,
Buffalo Design

buffalodesign
architecture & interiors

buffalodesign
architecture & interiors

1501 western
suite 500
seattle, wa
98101

1501 western
suite 500
seattle, wa
98101
206 467 6306
fax 206 624 1494

625 commerce
suite 310
tacoma, wa
98402
206 383 4250

buffalo**design**
architecture
& interiors

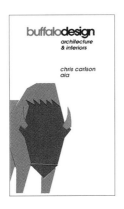

buffalo**design**
architecture
& interiors

chris carlson
aia

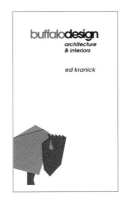

buffalo**design**
architecture
& interiors

ed kranick

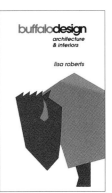

buffalo**design**
architecture
& interiors

lisa roberts

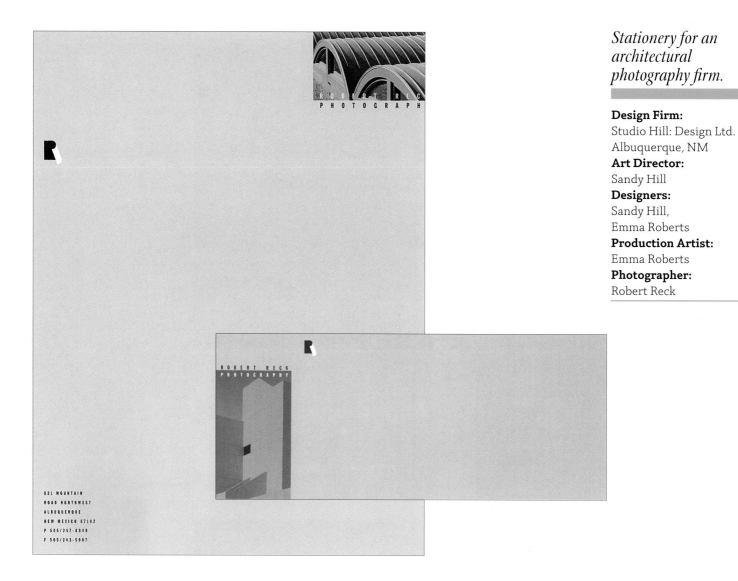

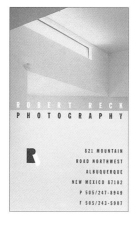

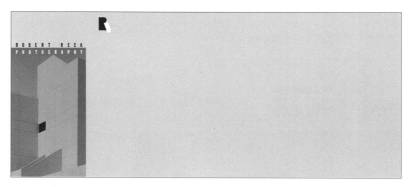

HANS ROTT PHOTOGRAPHY

Stationery for a commercial photographer.

Design Firm:
Pagliuco Design
Chicago, IL
Creative Director:
Michael Pagliuco
Designers:
Michael Pagliuco,
Jill Thomas

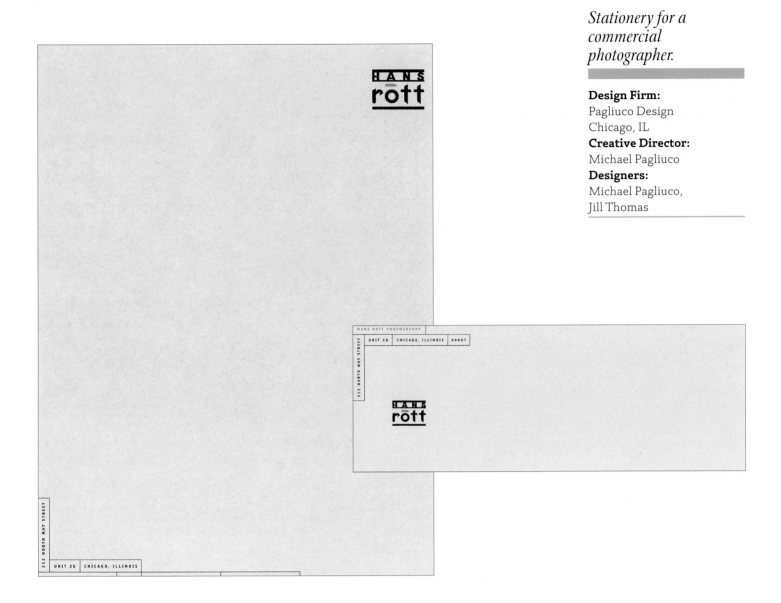

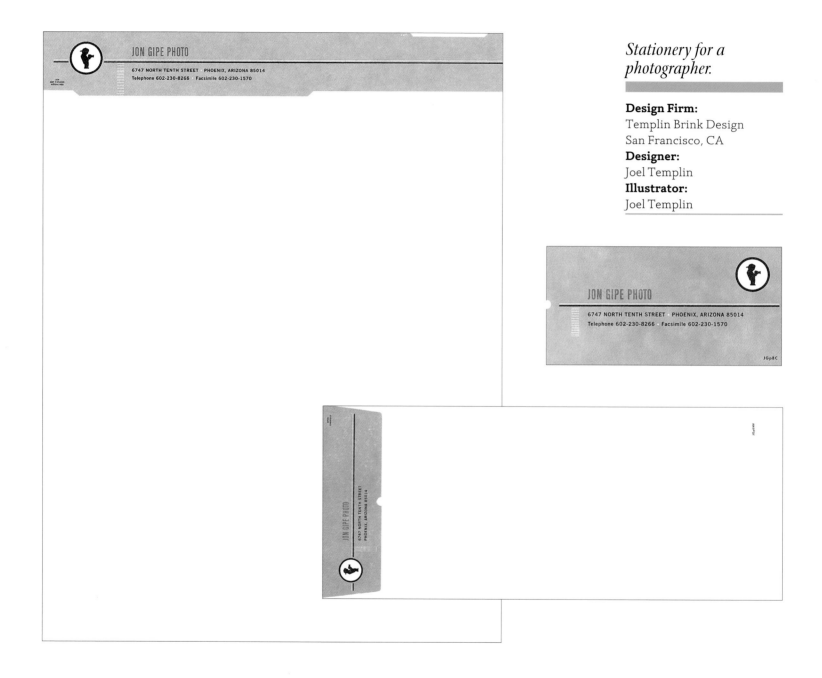

Stationery for a photographer.

Design Firm:
Templin Brink Design
San Francisco, CA
Designer:
Joel Templin
Illustrator:
Joel Templin

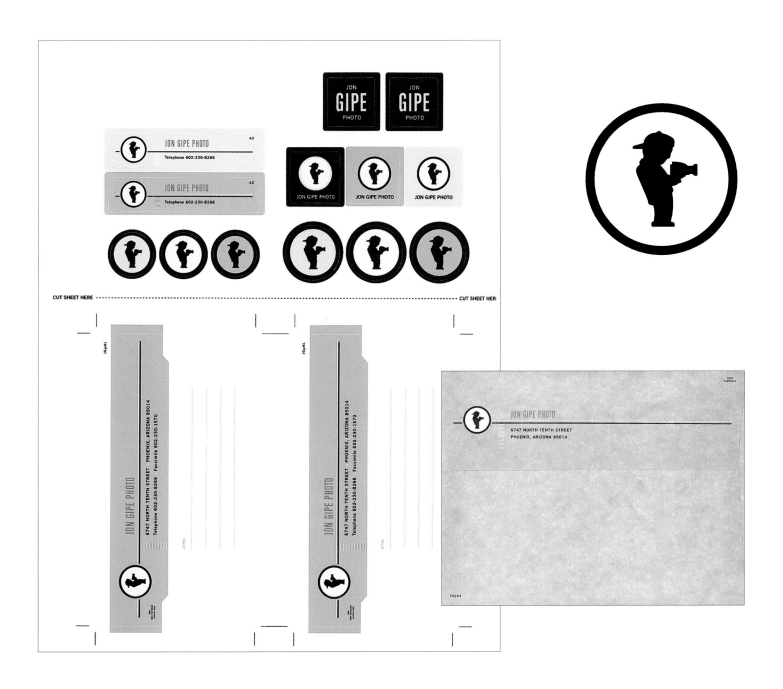

Stationery for an interior decorator.

Design Firm:
Real Art Design Group Inc.
Dayton, OH
Art Director:
Gregory Tobias
Designer:
Rachel Botting
Illustrator:
Rachel Botting

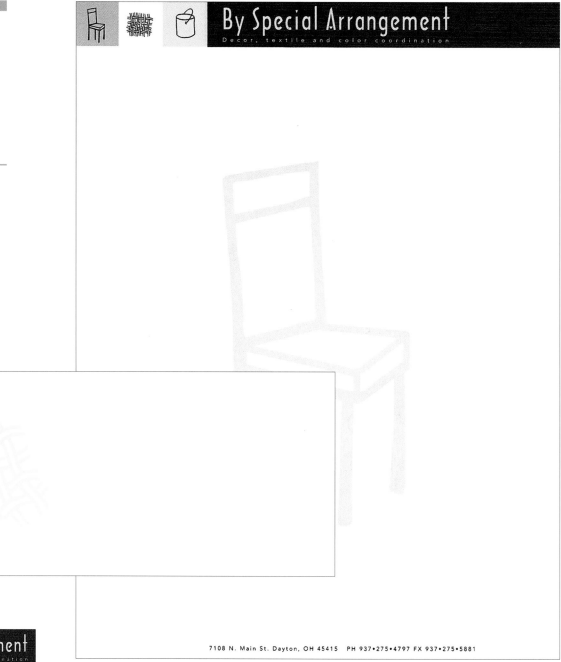

Stationery for an architectural firm.

Design Firm:
Kilter Incorporated
Minneapolis, MN
Creative Director:
Cynthia Knox
Art Director:
Jamie Parker
Designer:
Jamie Parker

HAGEN, CHRISTENSEN & MCILWAIN
ARCHITECTS

PH 612·904·1332 FAX 612·904·7366
212 THIRD AVENUE NORTH | SUITE 350 | MINNEAPOLIS, MN. 55401

HAGEN, CHRISTENSEN & MCILWAIN
ARCHITECTS
ROGER CHRISTENSEN, AIA
PH 612·904·1332 FAX 612·904·7366
CHRISTENSEN@HCMARCHITECTS.COM
212 THIRD AVENUE NORTH
SUITE 350
MINNEAPOLIS, MN. 55401

*Stationery for an
interior architecture
and design firm.*

Design Firm:
Kym Abrams Design, Inc.
Chicago, IL
Art Director:
Kym Abrams
Designer:
Kerry Lacoste

Hancock + Hancock Inc.
320 West Ohio Street
Chicago, Illinois 60610
T 312 587 1300
F 312 587 1399

Hancock2

Hancock2

Nina Hancock
Partner

Hancock + Hancock Inc.
320 West Ohio Street
Chicago, Illinois 60610
T 312 587 1300
F 312 587 1399
E nina@hancockinc.com

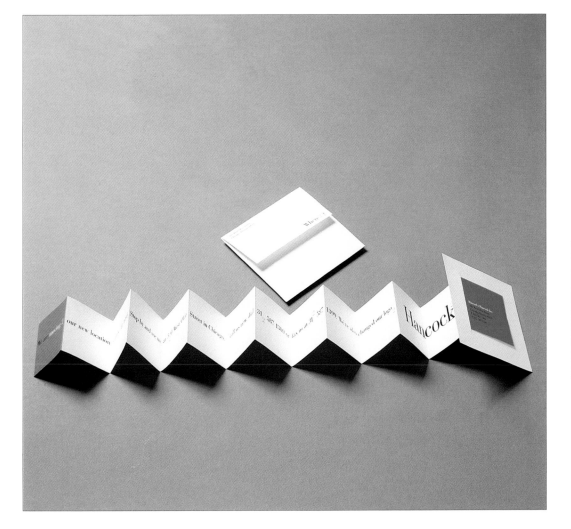

Hancock + Hancock Inc.
320 West Ohio Street
Chicago, Illinois 60610

Stationery for an architectural firm.

Design Firm:
Walker Creative, Inc.
Fayetteville, AR
Art Director:
Tim Walker
Designer:
Daniel Bertalotto

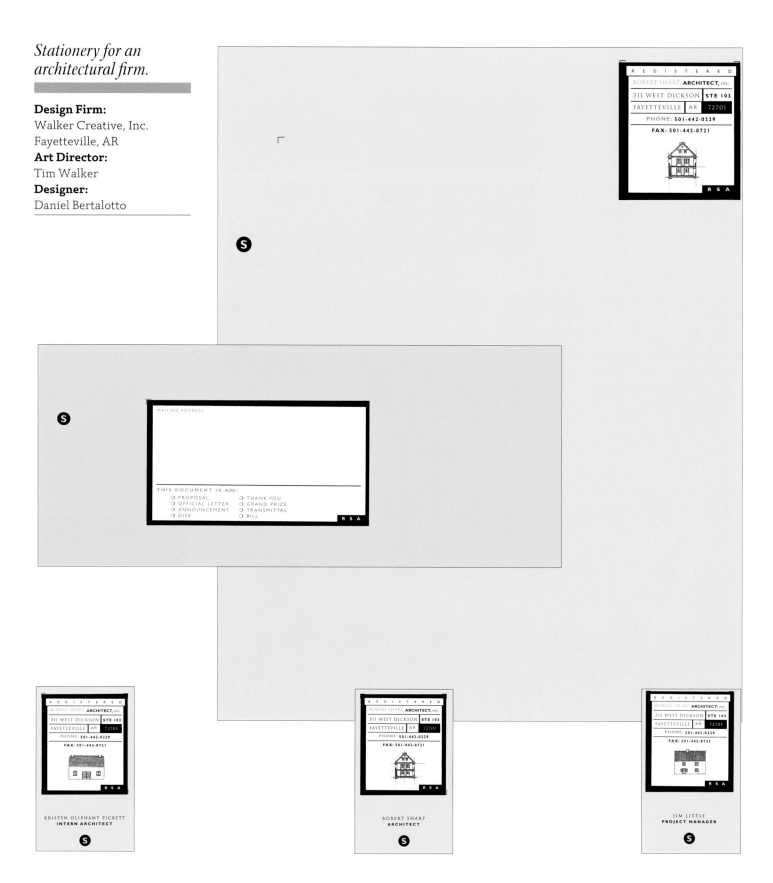

KAREN ASSOCIATES

Stationery for a picture editor of wildlife photography for books and magazines.

Design Firm:
The Office of Eric Madsen
Minneapolis, MN
Art Director:
Eric Madsen
Designers:
Eric Madsen,
Amy van Ert
Illustrator:
Dugald Stermer
Client:
Karen Altpeter

KAREN J. ALTPETER PRESIDENT/CREATIVE DIRECTOR

P.O. BOX 620616, MIDDLETON, WISCONSIN 53562 USA COURIER ONLY: 7006 HUBBARD AVENUE, MIDDLETON, WISCONSIN 53562 USA

TELEPHONE: (608)836-0159 FACSIMILE: (608)836-0160 E-MAIL: altpeter@concentric.net

Stationery for the publisher of Design Journal *magazine.*

Design Firm:
Sayles Graphic Design
Des Moines, IA
Art Director:
John Sayles
Illustrator:
John Sayles

DESIGN PUBLICATIONS
KEEPING TABS ON THE DESIGN INDUSTRY

DESIGN JOURNAL ADEX AWARDS PRODUCT SHOWCASE

DESIGN

Showcase

DESIGN PUBLICATIONS
KEEPING TABS ON THE DESIGN INDUSTRY

1431 7TH ST, SUITE 205
SANTA MONICA, CA 90401
(310) 394-4394 EXT. 117

JOHN PLATTER

President/CEO

1431 7TH STREET, SUITE 205
SANTA MONICA, CALIFORNIA 90401

DESIGN PUBLICATIONS
KEEPING TABS ON THE DESIGN INDUSTRY

FAX (310) 394-0966

Stationery for an architectural firm.

Design Firm:
Blank-Robert Kent Wilson
Washington, DC
Art Director:
Robert Kent Wilson
Designers:
Robert Kent Wilson,
Suzanne Ultman

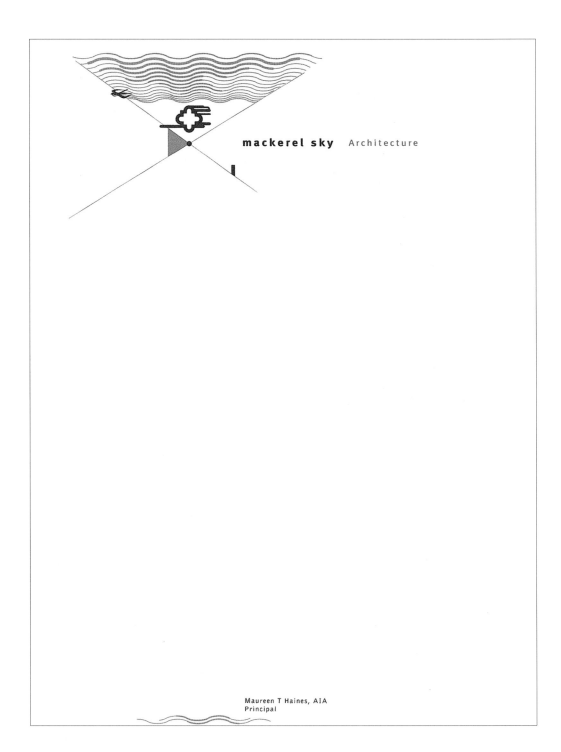

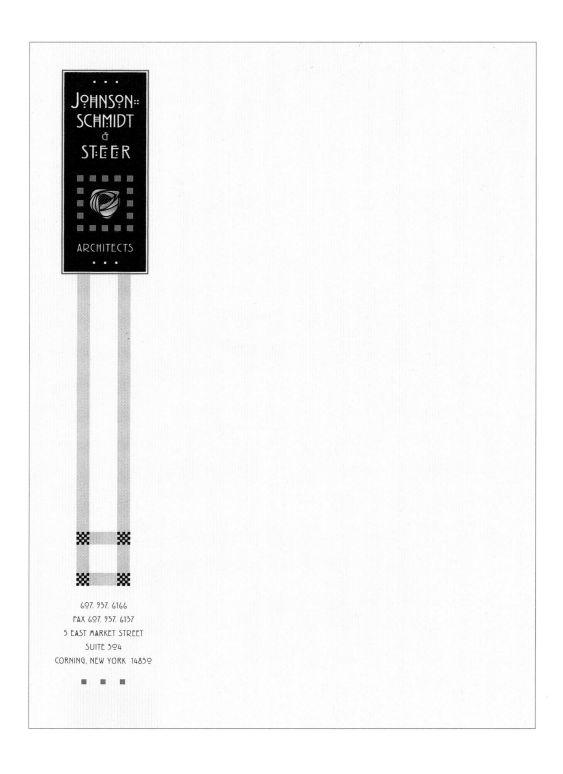

Design Firm:
Michael Orr & Associates
Corning, NY
Designers:
Michael R. Orr,
Elise Johnson-Schmidt

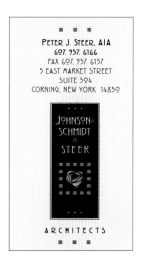

Stationery for a photographer.

Design Firm:
Alter Ego Design
Nashville, TN
Owner:
Gina R. Binkley
Art Director:
Gina R. Binkley
Designer:
Janice Booker
Photographer:
Tamara Reynolds

TAMARA REYNOLDS

photography

TAMARA REYNOLDS

photography

2700 EUGENIA AVENUE NASHVILLE, TENNESSEE 37211

2700 EUGENIA AVENUE NASHVILLE, TENNESSEE 37211 615.259.7504 *studio* 615.259.9946 *fax*

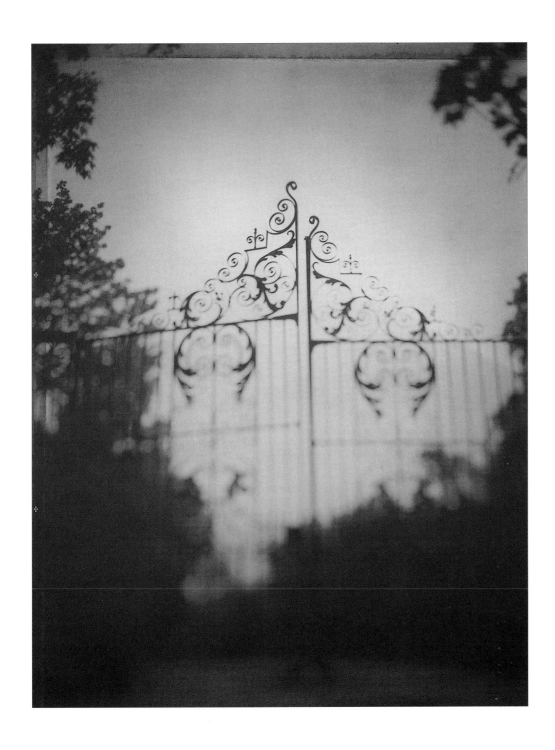

TAMARA
REYNOLDS
photography

2709 EUGENIA AVENUE · NASHVILLE · TENNESSEE · 37211
615.269.7504 studio 615.269.9946 fax

Stationery for an architectural design, master planning and interior design firm.

Design Firm:
Phoenix Creative
St. Louis, MO
Associate Creative Director:
Ed Mantels-Seeker
Art Director:
Ed Mantels-Seeker
Designer:
Ed Mantels-Seeker

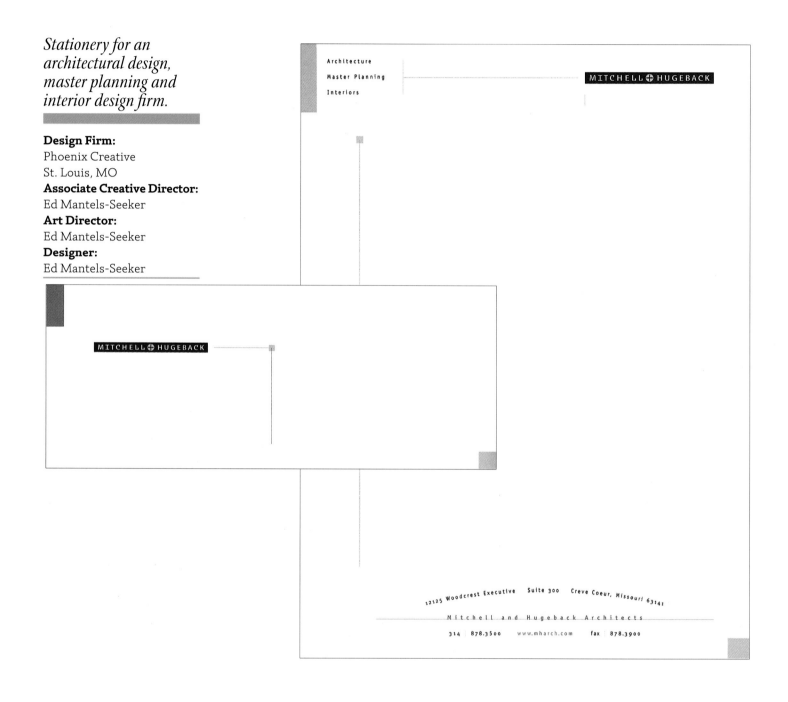

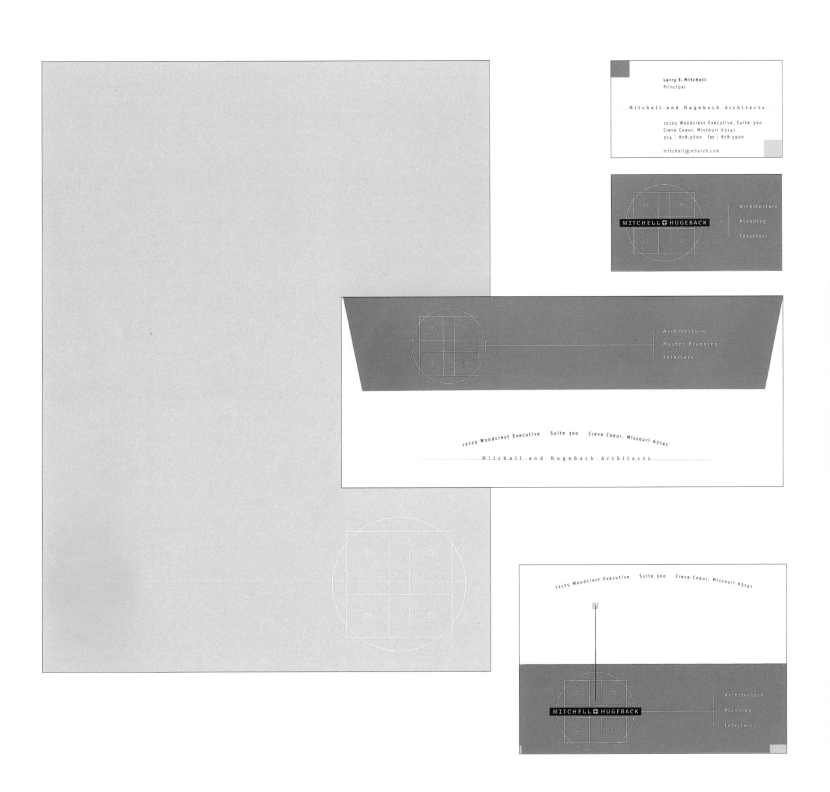

Larry E. Mitchell
Principal

Mitchell and Hugeback Architects

12125 Woodcrest Executive, Suite 300
Creve Coeur, Missouri 63141
314 | 878.3500 fax | 878.3900

mitchell@mharch.com

MITCHELL⊕HUGEBACK
Architecture
Planning
Interiors

Architecture
Master Planning
Interiors

12125 Woodcrest Executive Suite 300 Creve Coeur, Missouri 63141
Mitchell and Hugeback Architects

12125 Woodcrest Executive Suite 300 Creve Coeur, Missouri 63141

MITCHELL⊕HUGEBACK
Architecture
Planning
Interiors

*Stationery for a
culinary writer.*

Design Firm:
BSCW Design
New York, NY
Art Director:
Brian Wong
Designer:
Brian Wong
Illustrator:
Brian Wong

Lynn Leitner

Chef
Recipe Tester/Developer
Culinary Arts Writer

Lynn Leitner

20 Kimberly Drive
Ocean Township NJ 07712

Lynn Leitner

Chef · Recipe Tester/Developer · Culinary Arts Writer

20 Kimberly Drive
Ocean Township NJ 07712
Tel:732 922 4519
 732 295 1132 (summer)

20 Kimberly Drive
Ocean Township NJ 07712
Tel:732 922 4519
 732 295 1132 (summer)

*Stationery for a
photography studio.*

Design Firm:
Brainstorm, Inc.
Dallas, TX
Art Directors:
Chuck Johnson,
Tom Kirsch
Designer:
Tom Kirsch
Illustrator:
Tom Kirsch
Photographer:
Doug Davis

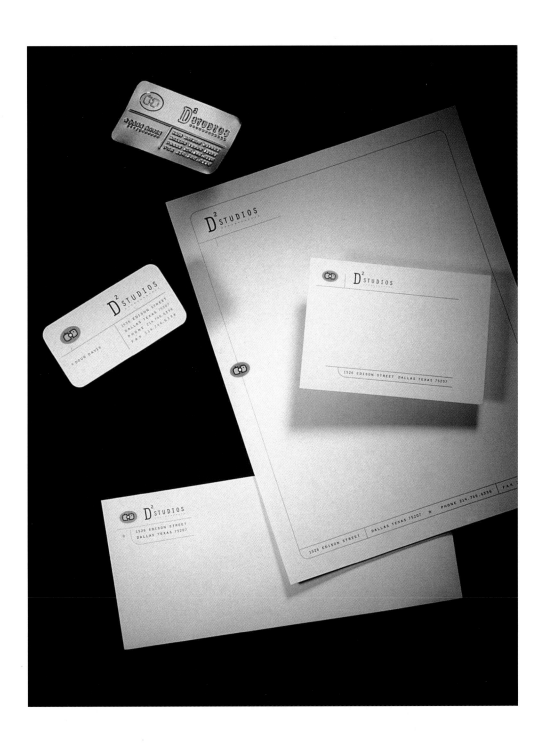

*Stationery for an editing
production house.*

Design Firm:
Blue
New York, NY
Art Director:
Timothy Jones

INVOICE

N°

●●●

TO

DATE

YOUR ORDER NUMBER

OUR JOB NUMBER

DESCRIPTION OF SERVICES

COMMENTS

●●●
704 BROADWAY
NEW YORK CITY
10003

212 228 7474
f 212 228 6085
www.nycjump.com

RESALE NUMBER

luis moreno

212 228 7474
212 228 6085 f
www.nycjump.com

704 BROADWAY NEW YORK CITY 10003

212 228 7474
212 228 6085 f
www.nycjump.com

michael saia

704 BROADWAY NEW YORK CITY 10003

barry stilwell

212 228 7474
212 228 6085 f
www.nycjump.com

704 BROADWAY NEW YORK CITY 10003

Stationery for a photography studio.

Design Firm:
Lewis Communications
Birmingham, AL
Art Director:
Bryant Fernandez
Photographer:
Bruce Nelson-Fernandez
Production:
Leigh Ann Motley

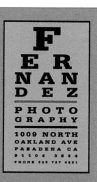

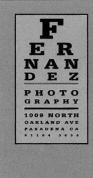

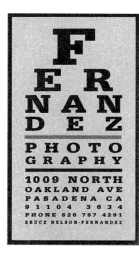

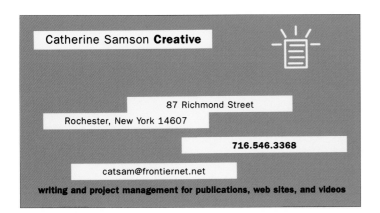

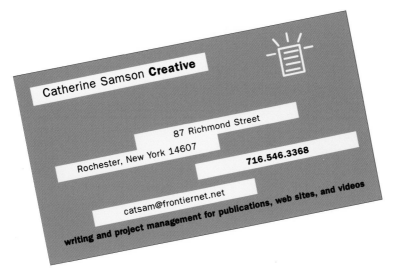

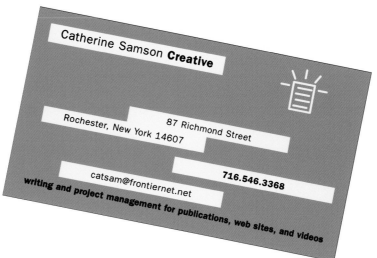

Business cards for a writer and project manager.

Design Firm:
Mannix Design
Rochester, NY
Creative Director:
Kathleen Mannix

Stationery for a self-taught folk artist from Memphis, Tennessee.

Design Firm:
Pensaré Design Group
Washington, DC
Creative Director:
Mary Ellen Vehlow
Designer:
Yael R. Konowe
Assistant Designer:
Colette Brandt
Production Manager:
Patrick Long

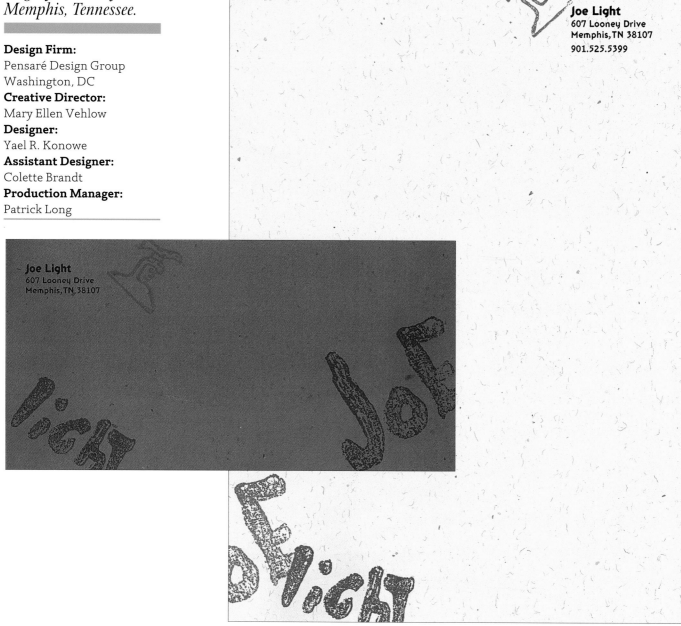

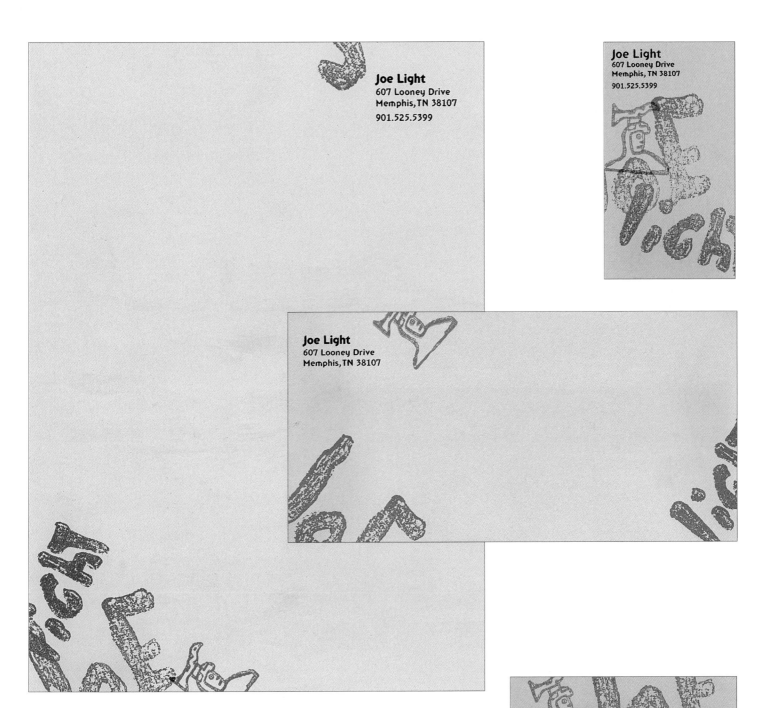

Joe Light
607 Looney Drive
Memphis, TN 38107

901.525.5399

Joe Light
607 Looney Drive
Memphis, TN 38107

Joe Light
607 Looney Drive
Memphis, TN 38107

901.525.5399

Joe Light
607 Looney Drive
Memphis, TN 38107

901.525.5399

Stationery for a photographer.

Design Firm:
Studio d Design
Minneapolis, MN
Designer:
Laurie DeMartino
Photographer:
Steve Belkowitz

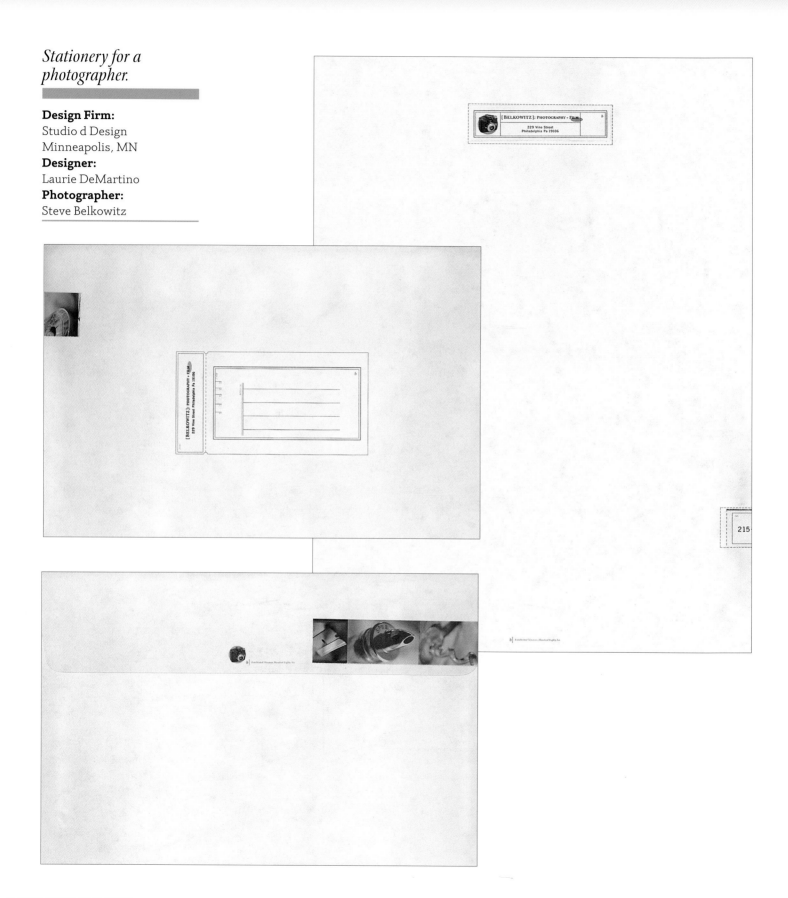

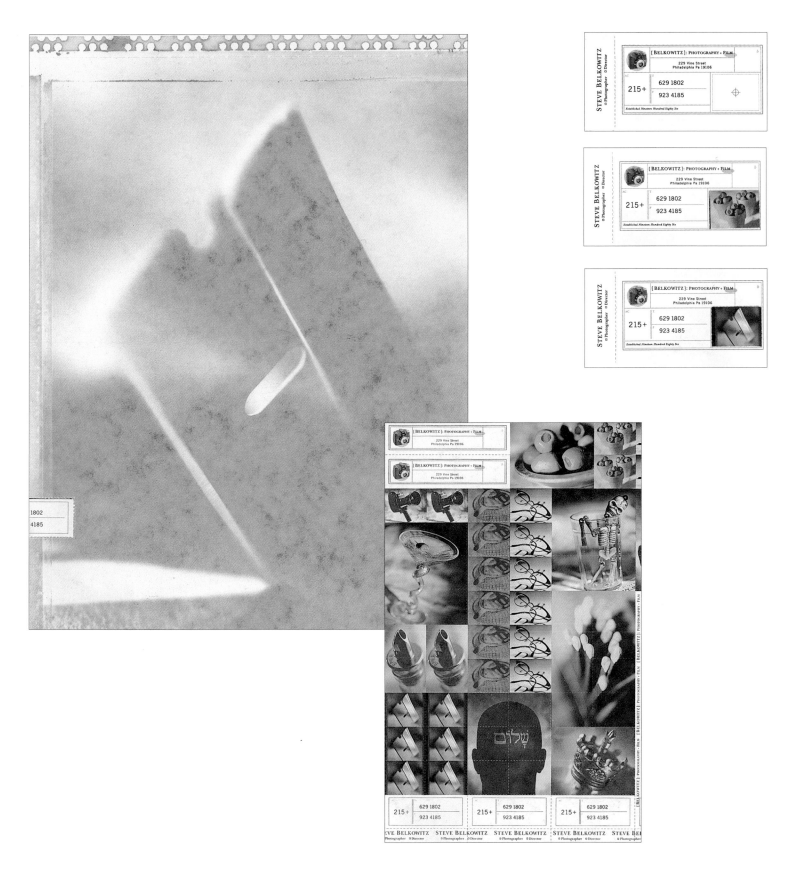

Stationery for a commercial photography studio.

Design Firm:
Basler Design Group
Cedar Rapids, IA
Art Director:
Drew Davies
Designers:
Bill Basler,
Bill Bollman,
Drew Davies

:a co-operative workshop established to craft dis
tinctive film-based and digital photography, fish
eye llc. is located at 819 north compton drive in
hiawatha, iowa (zip 52233). if using a phone to c
ontact the studio, call (319) 294-8610; a facsimi
le machine, (319) 294-9247. our elec.mail address
is fisheye@ia.net.

doug benton, photographer.

fisheye № 012502

:a co-operative workshop estab
lished to craft distinctive fi
lm-based and digital photograp
hy, fisheye llc. is located at
819 north compton drive in hia
watha, iowa (zip 52233). to co
ntact the studio by phone call
(319) 294-8610, by fax, try (3
19) 294-9247 instead. our digi
tal address is fisheye@ia.net.

fisheye

№ 056694

N⁰ 046194

:for information on the distinctive photogr
aphy contained in this envelope, contact fi
sheye, llc. at tele-phone number (319) 294-
8610 or fax number (319) 294-9247. to visit
us in person, stop by the studio on 819 nor
th compton drive in hiawatha, iowa (zip cd.
52233), u.s. of a.

fisheye

fisheye

:the return address for fisheye, llc.
is 819 no. compton drive in hiawatha,
iowa 52233, united states of america.

N⁰ 036467

Stationery for a company that produces and sells fishing and hunting art originals and prints.

Design Firm:
Bear Creek Studio
Rochester, NY
Art Director:
Bryan Charles
Designer:
Mark Cudney
Illustrator:
Mark Cudney

MARK CUDNEY
Bear Creek Studio
9468 Bronson Hill Rd.
Wayland, New York 14572
716/384-5876

*E*ntertainment

Anyone in the entertainment industry will tell you two things: 1) engaging the audience is a sine qua non for any type of performance and 2) people in entertainment like to be entertained.

The designers in this section evidently understood these bits of show-biz wisdom, as they made it their priority to make their clients' correspondence as engaging as possible. For some, this simply meant producing a hip and playful design. Others went the extra mile, turning stationery into a truly interactive experience.

Designer Brian De Los Santos is at the forefront of this latter group. His client, an actor named Stephen Garris, decided to quit his non-acting job and move to Hollywood. Garris's new business card needed to convey his profession, as well as advance his cause with producers, agents and directors. Obviously, an eye-catching and unusual design was in order, but De Los Santos found that none of his straight designs were doing the trick. It was when he started actually playing with the paper that his solution jelled. Putting a new spin on the traditional comedy and tragedy masks, he created a cartoon-style face, the sullen lower half of which flips up to reveal a smile, the actor's information, and the tagline, "Stephen Garris-Actor—Man of Many Faces." The folded card has already been a hit; the designer states, "A good friend of mine who happens to be a talent agent in L.A. saw the card and flipped." We can only assume he isn't just referring to the action required to unfold the business card.

Giving the recipients of stationery something to do is a great way to gain their attention. Potential customers who received mail from Jeff Lane, a TV and radio writer and producer, e-mailed and called him just to tell him how much they liked his letterhead. This wasn't just because of the lighthearted illustration of a typewriter spewing film instead of paper. Nor were they reacting to the varied colors and textures of the paper and enevelopes. What they really liked was the inclusion of a variety of short, amusing phrases (such as "Words is my life") that Lane had written, each appearing in a different area of the card and paper. As art director Michael Tucker states, "They enjoyed the surprise of 'finding' each one and looked forward to 'finding' the others." Simple pleasures, perhaps, but when everyone else sends their resumés on blank sheets of paper, a little visual levity goes a long way.

If you're still not convinced of the importance of whimsy, consider Tom Nynas, who designed the letterhead and business cards for the Sudbury Devils, a nonprofessional hockey team. Keeping the world of hockey well in mind, he rounded the corners of the stationery's heavy, white paper, and crossed it with the blue and red lines of a rink. "I wanted this to get away from corporate letterhead and relate more to the game," he explains. The appeal of his letterhead ended up reaching well beyond the ice: Fox River Paper was so impressed by his ingenious use of paper that they bought his design for their own promotions. It seems safe to say that Nynas's work scored a goal.

Letterhead for the management company of a children's songwriter.

Design Firm:
Delessert & Marshall
Lakeville, CT
Designer:
Rita Marshall
Illustrator:
Etienne Delessert
Client:
Productions Mary-Josée,
Paris, France

4 passage de la Main d'Or • 75011 Paris
Tel: (33) 01 49 29 55 50 • Fax: (33) 01 47 00 12 01
Web: http://www.henrides.com • Mail Compuserve: 106550.2164

4 passage de la Main d'Or • 75011 Paris • Tel: (33) 01 49 29 55 50 • Fax: (33) 01 47 00 12 01

Web: http://www.henrides.com • Mail Compuserve: 106550.2164

SARL au capital de 300,000 francs — RC Paris N° 311 462 444 — 82 B 3520

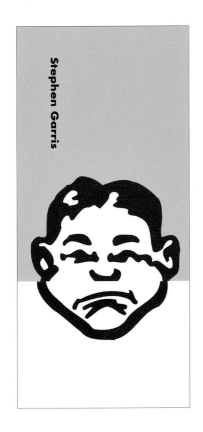

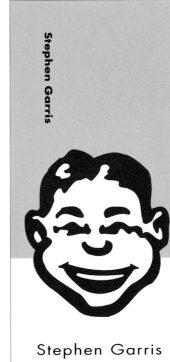

Stephen Garris

ACTOR
Man of many faces.

Represented by
Barbara Gray Talent
512-347-0818

sgarris@sicolamartin.com

hm 512.502.8174
pg 512.908.6301

*7117 Wood Hollow #732
Austin, Texas 78731*

Business card for an actor.

Designer:
Brian De Los Santos
Austin, TX
Art Director:
Brian De Los Santos

Stationery for a theatre.

Design Firm:
Dwight Douthit Design
Houston, TX
Art Director:
Dwight Douthit
Designer:
Patty McCormick
Illustrator:
Patty McCormick

STAGES
REPERTORY
THEATRE

Rob Bundy, *Artistic Director* • **Donald Hightower,** *Managing Director*

3201 Allen Parkway
Suite 101
Houston, Texas 77019-1897

STAGES
REPERTORY
THEATRE

3201 Allen Parkway, Suite 101 • Houston, Texas 77019-1897 • 713 / 527 - 0220 • 713 / 527 - 8669 fax • www.stagestheatre.com

STAGES REPERTORY THEATRE

CELEBRATING TWENTY YEARS OF DARING, INNOVATIVE THEATRE

Rob Bundy, *Artistic Director* • **Donald Hightower,** *Managing Director*

BOARD OF DIRECTORS
John G. Yeager, Chairman
Valerie J. Sherlock, Vice-Chairman
Mary Jane Taegel, President
Dodie Otey Jackson, Vice President
Carl Simpson, Treasurer
Susanne R. Bowers, Secretary

James P. Avioli
John N. Baird
Gary Barrett
Giorgio Bassa, Ph.D.
Mark Bergsrud
Coco Blaffer
Kimball Wayne Bockman, M.D.
Bob Boudreaux
Wendy K.B. Buskop
Kristi S. Cassin
Louise Gaylord
Carroll R. Goodman
Joanna Handel
Sharon Lay
Ernie Manouse
Melissa J. Matheny
Dennis McNabb
Elizabethe Payne
George Peterkin, III M.D.
John F. Platt
Stuart D. Purdy
James A. Reynolds
Mary Faye Way
Jean McConkey Yeager

ADVISORY BOARD
Dr. Sidney Berger, Chairman
Edward Albee
R. Edwin Allday
Bertrand Davezac
Mrs. William H. Guggolz, Jr.
Sam Havens
Mrs. Ford Hubbard, Jr.
Mrs. Emilie S. Kilgore
Jim Lehrer
Toby Mattox
Terrence McNally
Irl Mowery
Ted Swindley
Aline D. Wilson
Mrs. Wallace Wilson

3201 Allen Parkway, Suite 101 • Houston, Texas 77019-1897 • 713 / 527 - 0220 • 713 / 527 - 8669 fax • www.stagestheatre.com

STAGES REPERTORY THEATRE

Terry McClain
Controller

3201 Allen Parkway
Suite 101
Houston, Texas 77019-1897
713 / 527 - 0220, ext 204
713 / 527 - 8669 fax
tmcclain@stagestheatre.com

STAGES REPERTORY THEATRE

3201 Allen Parkway
Suite 101
Houston, Texas 77019-1897

Stationery for a writer and producer.

Design Firm:
Jeff Lane Creative
Houston, TX
Art Director:
Michael Tucker
Illustrator:
Michael Tucker
Writer:
Jeff Lane

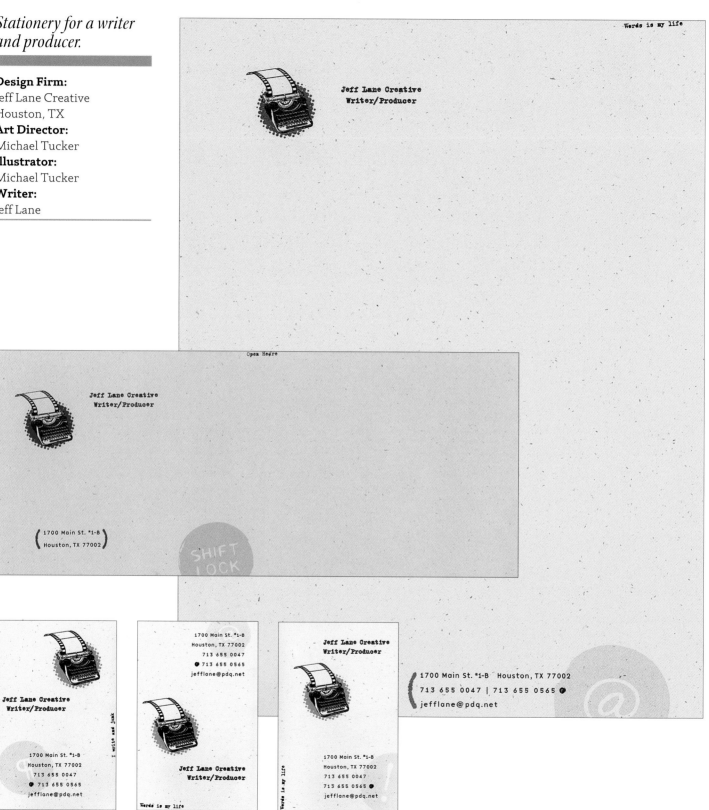

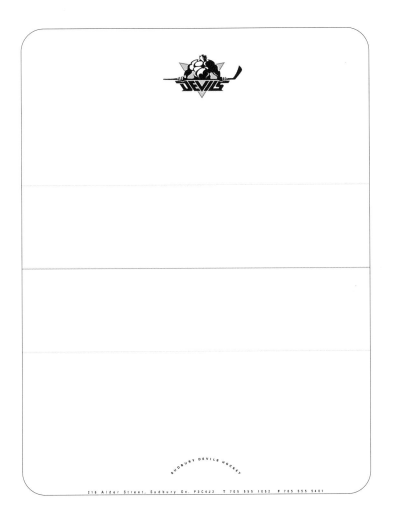

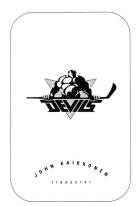

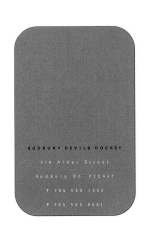

Stationery for a nonprofessional hockey team.

Designer:
Tom Nynas
Dallas, TX
Art Director:
Tom Nynas
Illustrator:
Tom Nynas

*Letterhead for a
musicians' manager.*

Design Firm:
Fresh Design
Nashville, TN
Art Director:
Glenn Sweitzer
Creative Director:
Kelly Wright
Designer:
Glenn Sweitzer

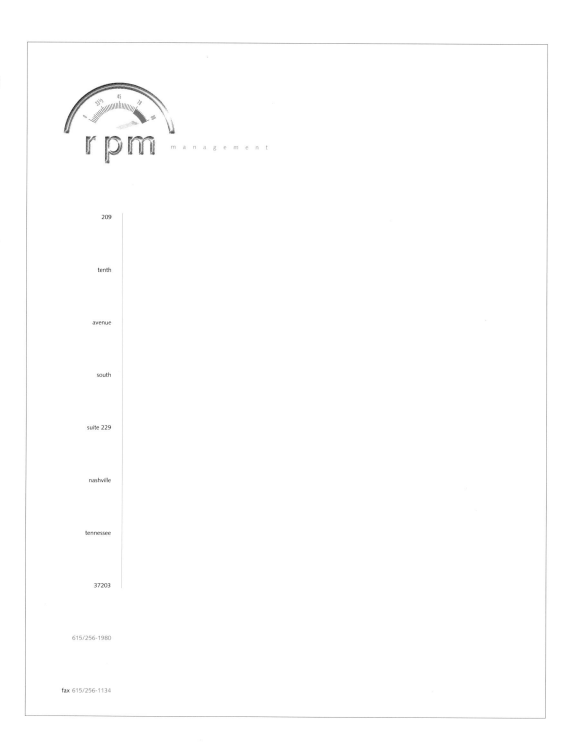

Identity system for a set-design company.

Design Firm:
Alter Ego Design
Nashville, TN
Art Director:
Gina R. Binkley
Designer:
Janice Booker

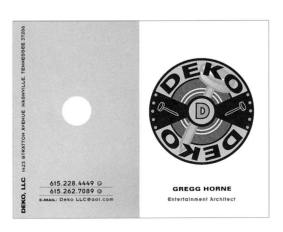

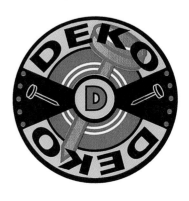

Stationery for a multi-media production and design company.

Design Firm:
Leighton C. Hubbell
Orange, CA
Designer:
Leighton C. Hubbell
Illustrator:
Leighton C. Hubbell

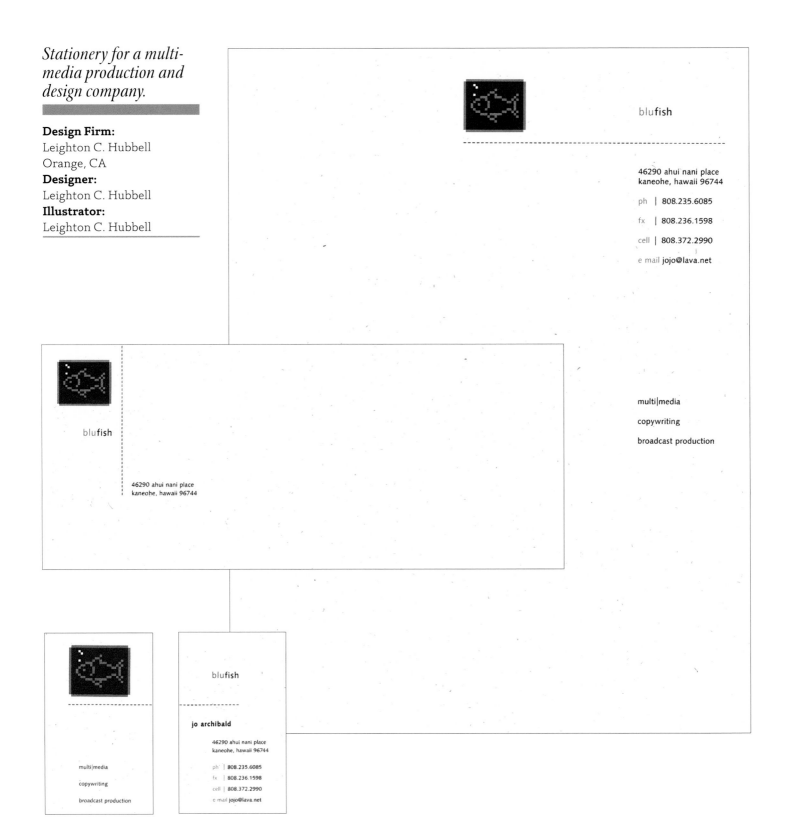

Services

One couldn't be blamed for thinking that the biggest problem facing designers of service-industry stationery must be lack of inspiration. The task of pepping up the image of, say, a roofer or a real-estate developer can't always be easy. However, this assumption clearly doesn't apply to the designers in this section. To begin with, quite a few were servicing service companies whose business is out of the ordinary. And the designers whose clients were more mundane not only freshened up those companies' images; they came out of the process with some great stories to tell after work.

In this latter category, we have the example of designer Nan Jorgensen, whose job it was to redesign the identity for Chek Tan and Company, an accounting firm. The unexciting nature of her client's business did not stop Jorgensen from arriving at an interesting, creative approach to the company's letterhead. "The new system needed to not only suggest accounting, but be distinctive and sophisticated," she explains. Since the company is based in Singapore, Jorgensen wanted to come up with something that would evoke Chek Tan's Asian roots, while also giving off an aura of dignified dependability. She settled on the image of an abacus, rendered loosely with brush and ink, and juxtaposed it with Palatino typeface. As the designer states, "The abacus most immediately suggests accounting, is an Asian creation, and has a neat, compact graphic form."

Sadly for Jorgensen, it turned out that designing the stationery was the easy part. Proofing the many unusual names of her client's employees proved difficult, so she was not surprised when a secretary called to tell her that there was a typo on one of the business cards. "I asked whose name had been misspelled, and she said, 'No, not a name. A title.' She was clearly uneasy about telling me exactly what the error was, so I rifled through my proofs searching for the offending card. Most had the title 'Certified Public Accountant' beneath the name, but one, inexplicably, read, 'Certified Pubic Accountant.' The designer herself had to pay for the reprinting.

Matt Graif might also have an after-hours story to pass around, but his tale would be more of the "oddball client" sort. His client, The Ticket Center, is a law firm with a rather unusual specialty: ticket offenses. Anything that warrants a traffic ticket, from parking violations to speeding, is handled by these lawyers. One might call them "meter watchers" (as opposed to ambulance chasers). Since, as Graif states, "Ticket offenses are not always serious," he decided to inject a little fun into the firm's stationery. The result: business cards that look like tickets complete with die-cut "punched" holes, perforation and check-boxes.

Parking violations might make for good anecdotes, but no story's juicier than one you're not allowed to tell. Chuck Pennington of Creative Partners claims that his client, Secret Weapon Marketing, does business that is "classified." His spare design tells us little more: The icon of an unidentifiable tool protruding from an open head hints at something ominous. But don't count on getting more information from the company itself. Pennington cautions, "If questioned, the client will deny they exist."

Stationery for a local messenger service.

Design Firm:
Bartels & Company, Inc.
St. Louis, MO
Art Director:
David Bartels
Designer:
Ron Rodemacher
Illustrator:
Shannon Kriegshauser

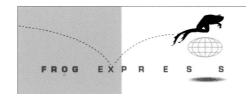

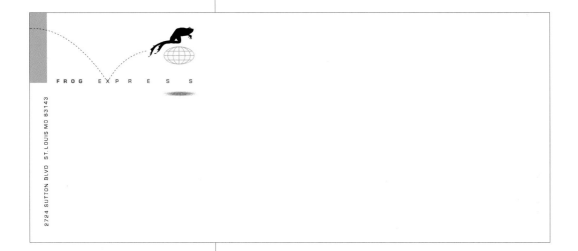

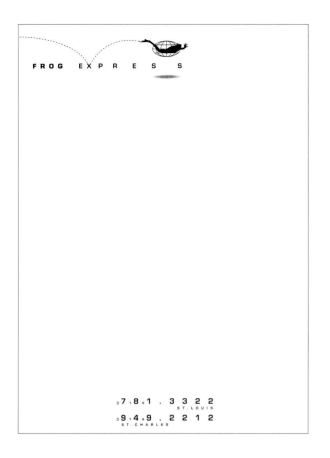

FROG EXPRESS

₃7₁8₄1 . 3 3 2 2
ST.LOUIS
₃9₄9 . 2 2 1 2
ST.CHARLES

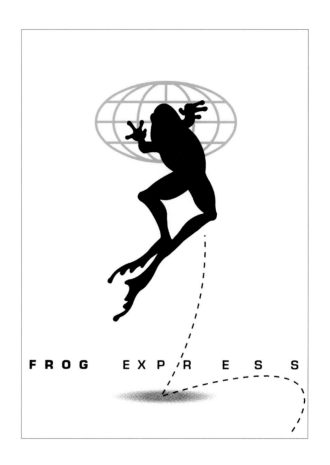

FROG EXP R E S S

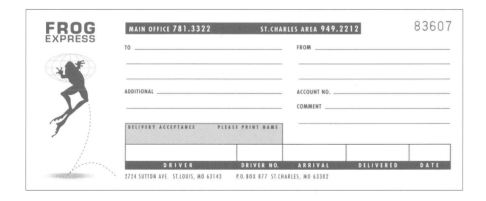

FROG
EXPRESS

MAIN OFFICE 781.3322 ST.CHARLES AREA 949.2212 83607

TO _____ FROM _____

ADDITIONAL _____ ACCOUNT NO. _____

COMMENT _____

DELIVERY ACCEPTANCE PLEASE PRINT NAME

| DRIVER | DRIVER NO. | ARRIVAL | DELIVERED | DATE |

2724 SUTTON AVE. ST.LOUIS, MO 63143 P.O. BOX 877 ST.CHARLES, MO 63302

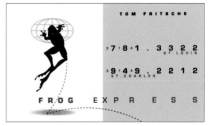

TOM FRITSCHE

₃7₁8₄1 . 3 3 2 2
ST.LOUIS

₃9₄9 . 2 2 1 2
ST.CHARLES

FROG EXP R E S S

*Stationery for a media
and public relations firm.*

Design Firm:
Greteman Group
Wichita, KS
Art Director:
Sonia Greteman
Designer:
James Strange

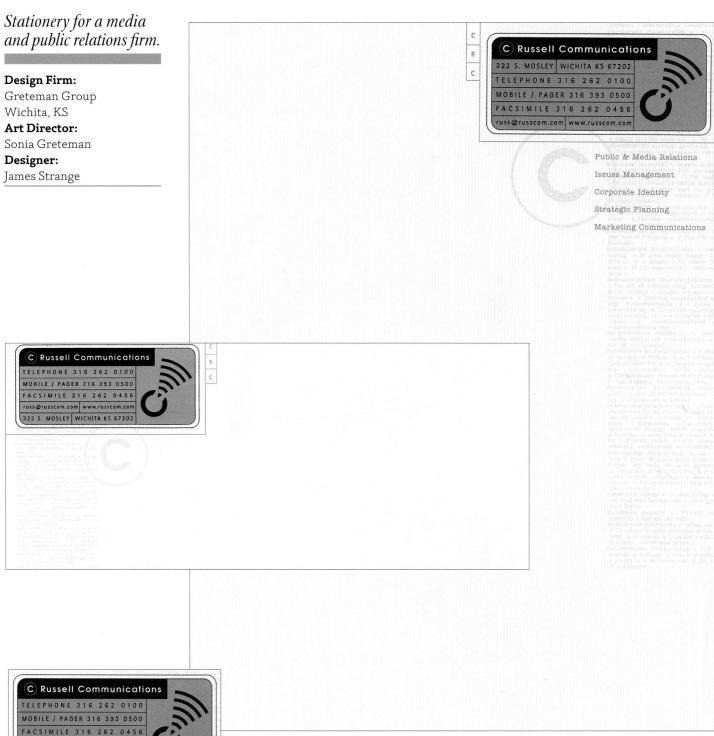

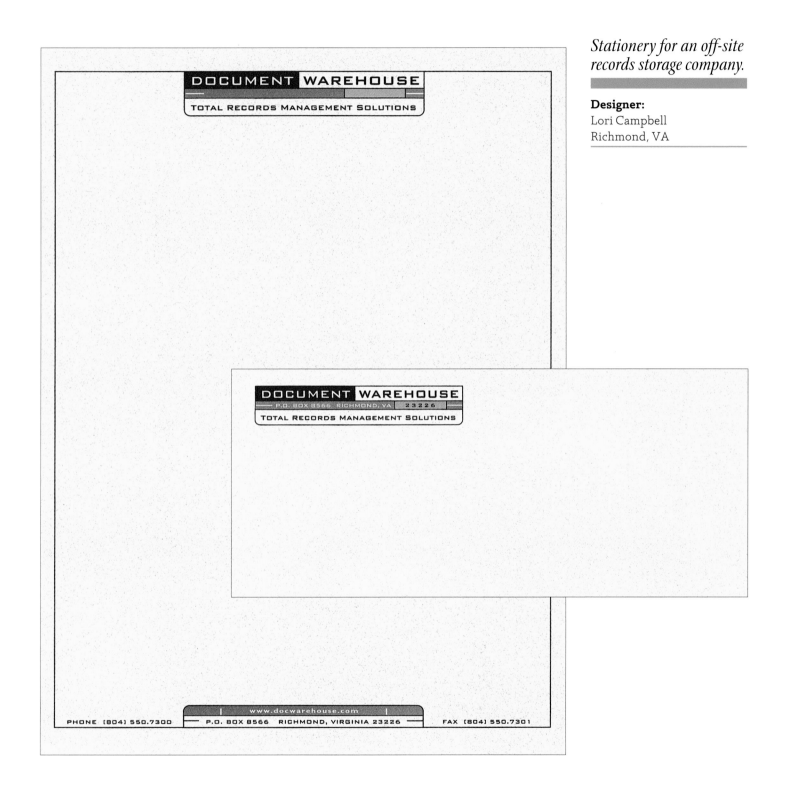

Stationery for an off-site records storage company.

Designer:
Lori Campbell
Richmond, VA

Stationery for a business that aids large companies in staging parties, events and conventions.

Design Firm:
Never Boring Design
Modesto, CA
Creative Director:
David Boring
Designer:
Alex Hillmer

office/studio
897 South Soderquist Rd.
Turlock, CA 95380 USA
209. 669. 6255
209. 664. 1515 Fax

San Francisco
Bay Area office
510. 583. 9370

1. 800. 331. 6255
www.jcdconcept2000.com

897 South Soderquist Rd.
Turlock, CA 95380 USA

j c d
CONCEPT 2000

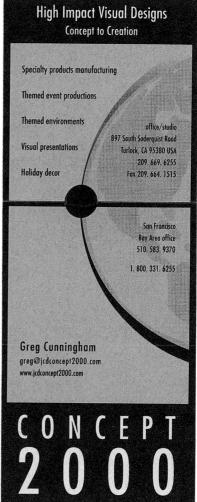

High Impact Visual Designs
Concept to Creation

Specialty products manufacturing

Themed event productions

Themed environments

Visual presentations

Holiday decor

office/studio
897 South Soderquist Road
Turlock, CA 95380 USA
209. 669. 6255
Fax 209. 664. 1515

San Francisco
Bay Area office
510. 583. 9370

1. 800. 331. 6255

Greg Cunningham
greg@jcdconcept2000.com
www.jcdconcept2000.com

CONCEPT 2000

Stationery for an accounting firm.

Design Firm:
Studio Hill: Design Ltd.
Albuquerque, NM
Art Director:
Sandy Hill
Designer:
Sandy Hill, Emma Roberts
Production Artist:
Emma Roberts
Creative Consultant:
Bruce Malott

m+

MEYNERS +
COMPANY, LLC
Certified Public Accountants/
Consultants to Business

500 Marquette NW, Suite 400
Albuquerque, New Mexico 87102
P 505/842-8290
F 505/842-1568
E cpa@meyners.com

m+

MEYNERS +
COMPANY, LLC
Certified Public Accountants/
Consultants to Business

500 Marquette NW, Suite 400
Albuquerque, New Mexico 87102

An Independent Member of the BDO Seidman Alliance

STEPHEN P. COMEAU, Esq.
General Counsel/Litigation
Support Specialist

m+

MEYNERS +
COMPANY, LLC
Certified Public Accountants/
Consultants to Business

500 Marquette NW, Suite 400
Albuquerque, New Mexico 87102
P 505/222-3521
F 505/842-1568
E cpa@meyners.com

*An Independent Member of the
BDO Seidman Alliance*

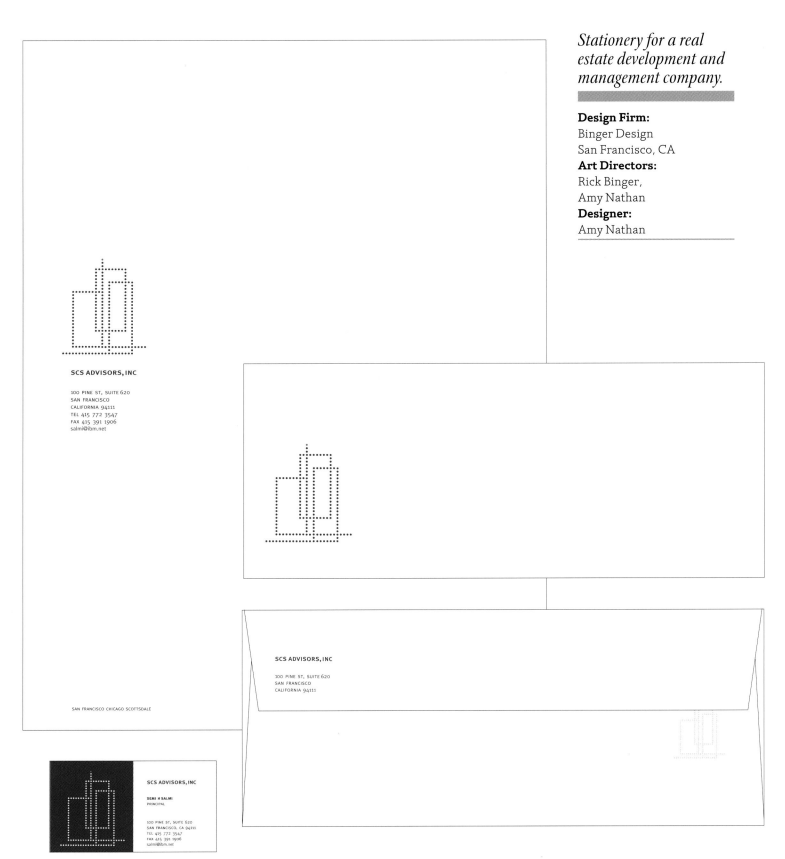

Stationery for a real estate development and management company.

Design Firm:
Binger Design
San Francisco, CA
Art Directors:
Rick Binger,
Amy Nathan
Designer:
Amy Nathan

SCS ADVISORS, INC

100 PINE ST, SUITE 620
SAN FRANCISCO
CALIFORNIA 94111
TEL 415 772 3547
FAX 415 391 1906
salmi@ibm.net

SAN FRANCISCO CHICAGO SCOTTSDALE

SCS ADVISORS, INC

100 PINE ST, SUITE 620
SAN FRANCISCO
CALIFORNIA 94111

SCS ADVISORS, INC

SEMI H SALMI
PRINCIPAL

100 PINE ST, SUITE 620
SAN FRANCISCO, CA 94111
TEL 415 772 3547
FAX 415 391 1906
salmi@ibm.net

Stationery for a roofing and re-roofing contractor.

Design Firm:
Musser Design
Columbia, PA
Owner:
Jerry King Musser
Creative Director:
Jerry King Musser
Designer:
Jerry King Musser

J.V. Heidler Roofing Company Inc.
209 Hazel Street
Lancaster Pennsylvania 17603
800-ROOFER3

J.V. Heidler Roofing of Delaware Inc.
830 Dawson Drive
Newark Delaware 19713
888-9ROOFER

J.V. Heidler Roofing of Virginia Inc.
801 Grove Road
Midlothian Virginia 23113
888-3ROOFER
License 033605

www.heidler.com

J.V. Heidler Roofing Company Inc.
209 Hazel Street
Lancaster Pennsylvania 17603

J.V. Heidler Roofing of Delaware Inc.
830 Dawson Drive
Newark Delaware 19713

J.V. Heidler Roofing of Virginia Inc.
801 Grove Road
Midlothian Virginia 23113

 J.V. Heidler Roofing Company Inc.
209 Hazel Street
Lancaster Pennsylvania 17603
717-397-1584 voice
717-397-1686 fax
800-ROOFER3
www.heidler.com

Gary Neyman
Service Manager + Crane Operator
info@heidler.com

J.V. Heidler Roofing Company Inc.

Protecting Your Investment

Stationery for a commercial real estate firm.

Design Firm:
Wise Marketing & Design
Atlanta, GA
Creative Director:
Jim Wise
Designer:
Patrick Durgin-Bruce

ALAN JOEL PARTNERS

Commercial Real Estate Brokerage & Investment

3715 Northside Parkway, NW
400 Northcreek, Suite 210
Atlanta, Georgia 30327
tel 404-869-2600 *fax* 404-869-2601

ALAN JOEL PARTNERS

Commercial Real Estate Brokerage & Investment

3715 Northside Pkwy, NW • 400 Northcreek, Ste. 210 • Atlanta, GA 30327

ALAN JOEL PARTNERS

Commercial Real Estate Brokerage & Investment

Alan L. Joel
Principal

CCIM

3715 Northside Pkwy, NW
400 Northcreek, Suite 210
Atlanta, Georgia 30327

tel 404-869-2600
dir 404-869-2602
fax 404-869-2601

ajoel@ajpartners.com

UPHOLSTERY SOLUTIONS
1818 E.MADISON PHOENIX, AZ 85034

Stationery for a company that re-upholsters furniture.

Design Firm:
Stevens Tarr
Scottsdale, AZ
Creative Director:
Darren Davis
Designer:
Dennis Garcia

UPHOLSTERY SOLUTIONS
1818 E.MADISON PHOENIX, AZ 85034

CUSTOM SEATING • UPHOLSTERY SERVICES

Tel. No.
602
462.9413
FAX) 602 462.9680

CUSTOM SEATING • UPHOLSTERY SERVICES

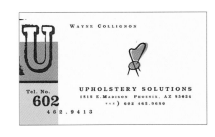

WAYNE COLLIGNON

UPHOLSTERY SOLUTIONS
1818 E.MADISON PHOENIX, AZ 85034
FAX) 602 462.9680
Tel. No.
602
462.9413

CUSTOM SEATING • UPHOLSTERY SERVICES

Stationery for a resort condominium developer.

Design Firm:
FJCandN
Salt Lake City, UT
Designers:
Christian Hansen,
Scott Rockwood

TETON CLUB

Jackson Hole, Wy.

TETON CLUB

Jackson Hole, Wy.

TETON CLUB

Jackson Hole, Wy.

P.O. BOX 158 TETON VILLAGE, WY 83025 *Phone* (307) 734 0745 *Fax* (307) 734 0825

Stationery for a law firm that specializes in minor ticket offenses.

Design Firm:
Graif Design
Nixa, MO
Owner:
Matt Graif
Designer:
Matt Graif

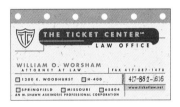

BARRICK ROOFING

Stationery for a commercial and industrial roofing company.

Design Firm:
Sayles Graphic Design
Des Moines, IA
Art Director:
John Sayles
Illustrator:
John Sayles

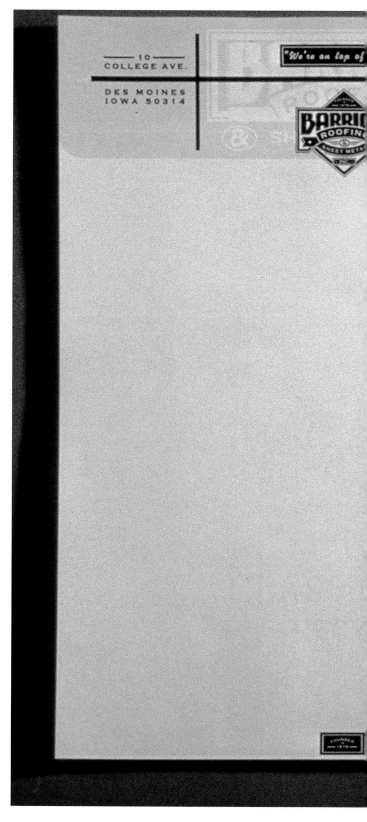

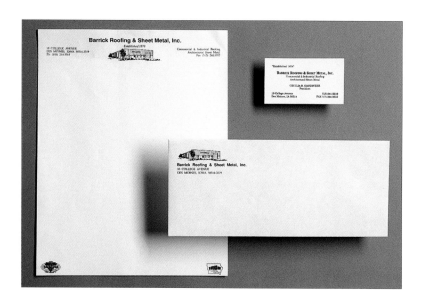

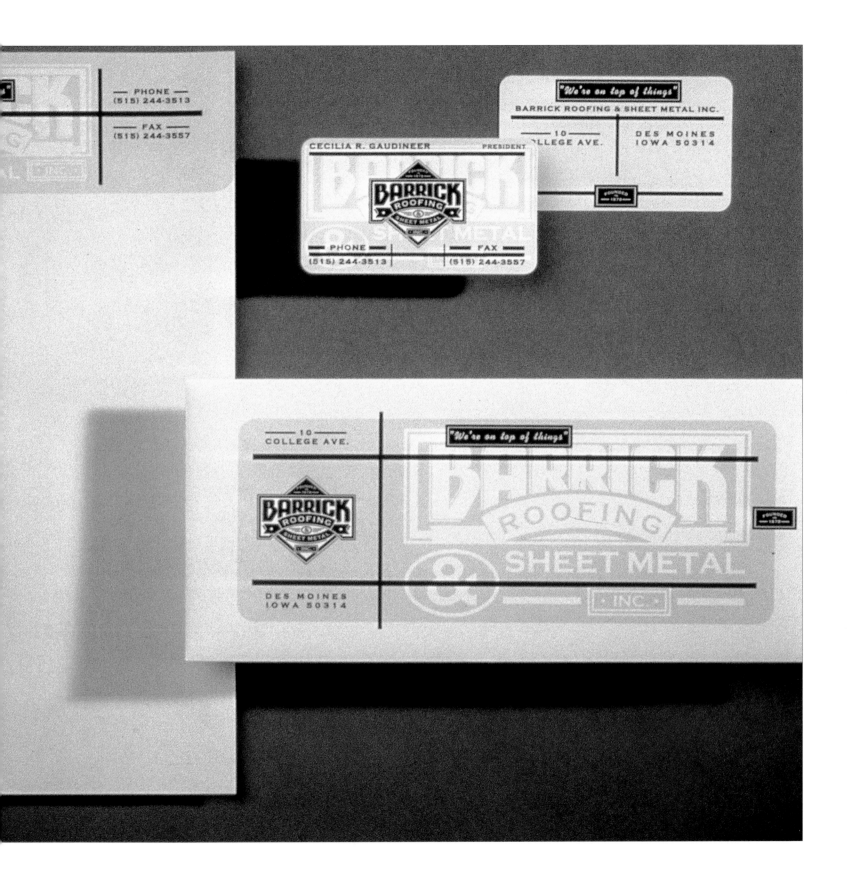

Stationery for a company that provides organizational development, leadership and strategic planning for CEOs, HR directors, and company executives.

Design Firm:
Hall Kelley, Inc.
Marine on St. Croix, MN
Designer:
Michael Hall

Management
Consultants

5200 Willson Road
Suite 402
Edina, Minnesota
55424

T: 612-925-1757
F: 612-925-0397
E: jbyrd@rbyrdco.com

Jacqueline L. Byrd, PhD
President

Management
Consultants

5200 Willson Road
Suite 402
Edina, Minnesota
55424

T: 612-925-1757
F: 612-925-0397
E: jbyrd@rbyrdco.com

Stationery for an accounting firm.

Design Firm:
Jorgensen Design
Salt Lake City, UT
Designer:
Nan Jorgensen

CHEK ⊞ TAN
AND COMPANY
A CERTIFIED PUBLIC ACCOUNTING FIRM

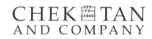

CHEK ⊞ TAN
AND COMPANY
A CERTIFIED PUBLIC ACCOUNTING FIRM

1670 PINE STREET, SECOND FLOOR
SAN FRANCISCO, CALIFORNIA 94109-4596
TEL: 415.673.8573 FAX: 415.673.0883

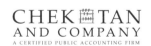

CHEK ⊞ TAN
AND COMPANY
A CERTIFIED PUBLIC ACCOUNTING FIRM

CANDY WU

1670 PINE STREET, SECOND FLOOR
SAN FRANCISCO, CALIFORNIA 94109-4596
TEL: 415.673.8573 FAX: 415.673.0883
chektan@slip.net

1670 PINE STREET, SECOND FLOOR
SAN FRANCISCO, CALIFORNIA 94109-4596
TEL: 415.673.8573 FAX: 415.673.0883
chektan@slip.net

Stationery for a marketing firm involved in "classified" activities.

Design Firm:
Creative Partners
Seattle, WA
Creative Directors:
Dick Settig,
Chuck Pennington

SECRET WEAPON MARKETING

1310 Montana Avenue
Santa Monica, CA 90403
t: 310.656.5999
f: 310.656.6999

After reading document, please swallow.

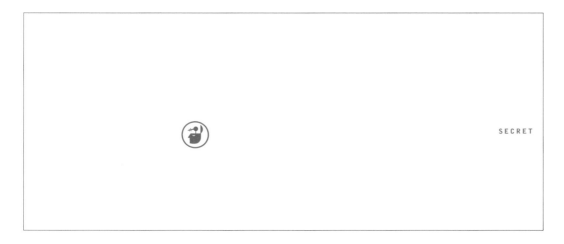

SECRET

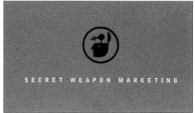

SECRET WEAPON MARKETING

WEAPON MARKETING 1310 Montana Avenue, Santa Monica, CA 90403

Missions | Strategies | Executions

Patrick K. Adams
Managing Director

1310 Montana Avenue, Santa Monica, CA 90403
t: 310.656.5999 f: 310.656.6999

Stationery for a printer.

Design Firm:
Deep Design
Atlanta, GA
Designer:
Rick Grimsley

RAYNAT
GRAPHIC SYSTEMS

R

SINCE 1924

QUANTITY	ITEM CODE	DESCRIPTION	UNIT PRICE	AMOUNT

Raynat 450 Hunters Crossing Dr Atlanta GA 30328 TEL 770 393 4300 FAX 770 393 4247

Project Management Planning Pre-press Printing Bindery Fulfillment Distribution

RAYNAT
GRAPHIC SYSTEMS

R

JOB#	☐ PROOF O.K.
DATE	☐ O.K. WITH CORRECTIONS
O.K.'d BY	☐ SHOW ANOTHER PROOF

450 Hunters Crossing Dr Atlanta GA 30328

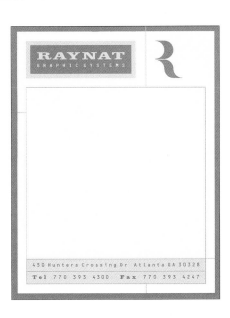

450 Hunters Crossing Dr Atlanta GA 30328
Tel 770 393 4300 Fax 770 393 4247

Stationery for a company that helps HR managers find new employees.

Design Firm:
Neo Design
Washington, DC
Art Directors:
Kristi Antonneau,
Harold Riddle
Designers:
Kristi Antonneau,
Harold Riddle,
Laila Rezai,
Hunter Wimmer

alexus
Rhonda L. Hamner
vice president client services
director of programs

555 Quince Orchard Rd.
Suite 480
Gaithersburg, MD 20878
main: 301.417.0500
facsimile: 301.519.8308
email: hamnerr@alexus.com
www.alexus.com

the right people

alexus

555 Quince Orchard Road / Suite 480 / Gaithersburg, MD 20878 / voice: 301.417.0500 / facsimile: 301.519.8300 / www.alexus.com

Landscape Maintenance
& Contracting

CareScape

P.O. Box 11738
Glendale, Arizona 85318

CareScape

P.O. Box 11738
Glendale, Arizona 85318
(602) 583-8700
Fax (602) 583-8500

Stationery for a landscape maintenance company.

Design Firm:
Richardson or Richardson
Phoenix, AZ
Creative Director:
Forrest Richardson
Designer:
Nathan Naylor

Stationery for a car-wash service.

Agency:
Broderick/Bates Advertising
Jackson, MS
Senior Art Director:
Morris B. Spears

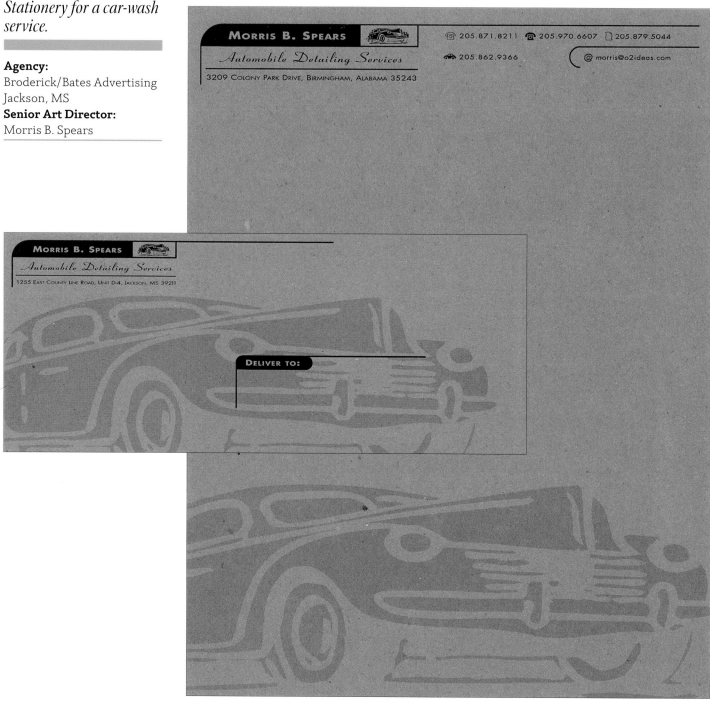

Business card for a plumbing company.

Designer:
Darlene J. Alberti
Long Branch, NJ

Stationery for a marketing firm.

Design Firm:
Decker Design
New York, NY

Art Director:
Lynda Decker

Designers:
Lynda Decker,
Kevin Lamb

Illustrators:
Lynda Decker,
Kevin Lamb

Friedin Promotional Group
195 Fairfield Avenue
Suite 1A
West Caldwell
New Jersey 07006
P 973.618.0390
F 973.618.0394

Friedin Promotional Group
195 Fairfield Avenue
Suite 1A
West Caldwell
New Jersey 07006
P 973.618.0390
F 973.618.0394

Janet Pascale

Friedin Promotional Group

195 Fairfield Avenue
Suite 1A
West Caldwell
New Jersey 07006

P 973.618.0390
F 973.618.0394

Janet Pascale

Friedin Promotional Group

195 Fairfield Avenue
Suite 1A
West Caldwell
New Jersey 07006

P 973.618.0390
F 973.618.0394

Janet Pascale

Friedin Promotional Group

195 Fairfield Avenue
Suite 1A
West Caldwell
New Jersey 07006

P 973.618.0390
F 973.618.0394

Janet Pascale

Friedin Promotional Group

195 Fairfield Avenue
Suite 1A
West Caldwell
New Jersey 07006

P 973.618.0390
F 973.618.0394

Janet Pascale

Friedin Promotional Group

195 Fairfield Avenue
Suite 1A
West Caldwell
New Jersey 07006

P 973.618.0390
F 973.618.0394

Stationery for a landscaping company.

Design Firm:
Blain/Olsen/White/Gurr
Salt Lake City, UT
Designer:
Jay Hill

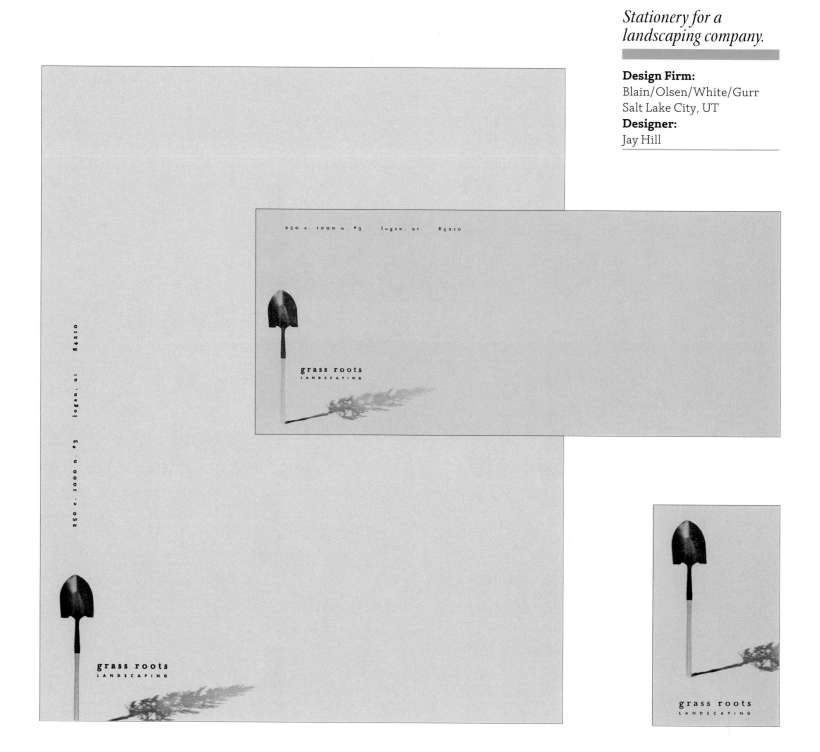

*N*on-Profits & Special Events

There's something about special events and non-profit organizations that seems to spark creativity in graphic designers. The celebratory nature of some events, perhaps, gets them in the right mood; and non-profit clients tend to be open-minded when it comes to design ideas, a quality that does more than anything to get the creative imagination going. Also, whether one is designing for a good cause or a good time, it helps to know that one is supporting an endeavor that benefits people.

When the purpose of an event is dear to the designer's heart, the project at hand can only become more enjoyable. The designers at Meta Design had the pleasantly challenging task of producing stationery for FUSE 98: Beyond Typography, a conference on "how creative thinking effects us as people in a world of ever-changing technology." This job posed some interesting problems for the firm. As designer Rick Lowe says, "How do you package innovation and experimentation?" How, indeed! The issue seems oxymoronic, but Meta found a solution. "Our approach was to make all of the identity pieces feel laboratory-like and scientific—to make the packaging of the ideas quiet and let the ideas of the work be the star." This take on the problem worked well: The simple design of the stationery, with its emphasis on type, makes subtle reference to the business of creativity, and allows the viewer plenty of space to consider the ideas brought forth at the conference. In other words, Meta perfectly conveys the essence of the event, which was a forum for the exploration of design's role in a fast-moving, tech-heavy world.

Fahlgren's client, The Cultural Center of Fine Arts in Parkersburg, West Virginia, also appealed to the designers' sensibilities. After all, what designer wouldn't be enthusiastic about working on the identity for an art museum? Fahlgren had the additional job of giving the center a new look, one that marked its new location while differentiating it from a local organization that focuses on the performance arts. Art director Anne Johnson's choice of a picture frame as the stationery's main visual component lets viewers immediately know the Center's purpose. The die-cut square at the frame's center completes the concept. As Johnson explains, "It creates an awareness that art and beauty are all around us." This is the kind of design statement that's already a pleasure to make, but the Center managed to enhance the pleasure. "It was one of those rare projects where the client gave us the complete flexibility to create their image," she says. "We only presented one concept and they allowed us to run with it."

The requirements of SK Designworks' client, Do Something, also seem to have been fairly easygoing (especially considering the organization's commanding name). "They wanted to be 'hip,'" states the firm's art director, Soonduk Krebs. The non-profit, which encourages young people to accept the responsibility of leadership roles, wanted a stationery set that would appeal to 18-to-24-year-olds. SK Design decided to keep the organization's original logo, making some small changes to appeal to a younger audience. An energetic, colorful approach to type, combined with the rough-and-ready look of brown paper, gave the set the edge it needed to convey a can-do spirit.

Pentagram's client needed something a little *less* "hip," if anything. New York City's Centennial, celebrating the anniversary of the five boroughs' unification, warranted something sophisticated and locale-appropriate. The designers at Pentagram used a three-color system on cream paper for the stationery and developed a logo evoking one of New York's most recognizable assets. "The logo resembles the tile-work of the of the city's subway system," explains art director Woody Pirtle. "It's symbolic of the transportation arteries that tie the boroughs together." Pentagram's design, aside from its innate worth, also has the distinction of being the only one in this section to be converted into edible form . . . and ingested by Mayor Rudolph Giuliani. For the launch of the Centennial Celebration, the logo was made into a cake and cut ceremonially by His Honor. Pentagram deserves particular commendation on this count: It may have been the only occasion when Giuliani found publicly-funded art palatable.

Stationery for an art museum and education center.

Design Firm:
Fahlgren
Parkersburg, WV
Creative Director:
Lee Sloan
Art Director:
Anne Johnson
Photographer:
Jim Osborn

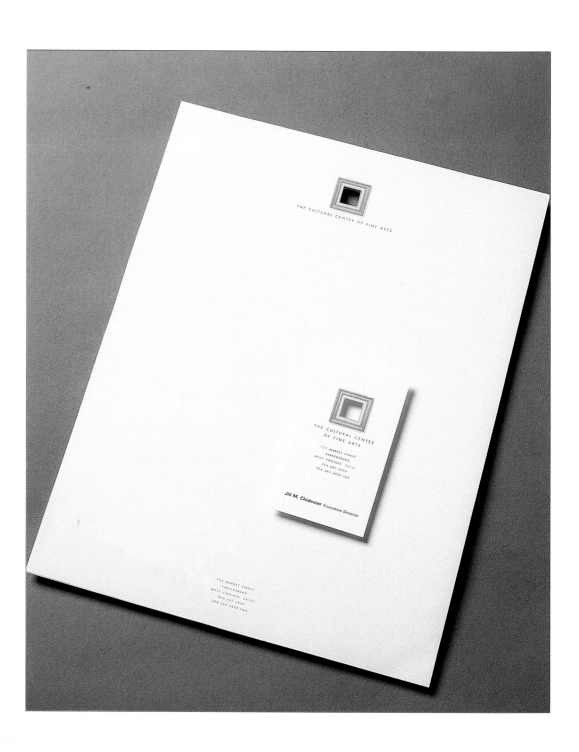

Stationery for a conference for graphic designers and other creatives.

Design Firm:
Meta Design
San Francisco, CA
Design Directors:
Rick Lowe,
Neville Brody
Designer:
Mike Abbink
Writers/Editors:
Jon Wozencroft,
Christopher Myers

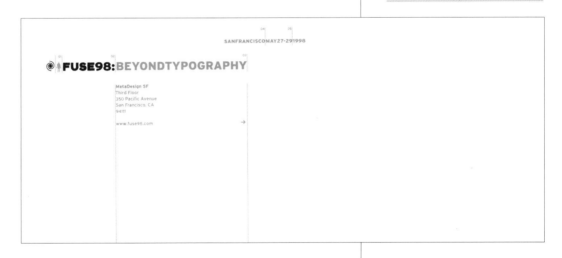

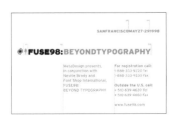

Stationery for an organization that motivates young people to effect change and assume leadership.

Design Firm:
SK Designworks
Philadelphia, PA
Art Director:
Soonduk Krebs
Designer:
Paul Kepple

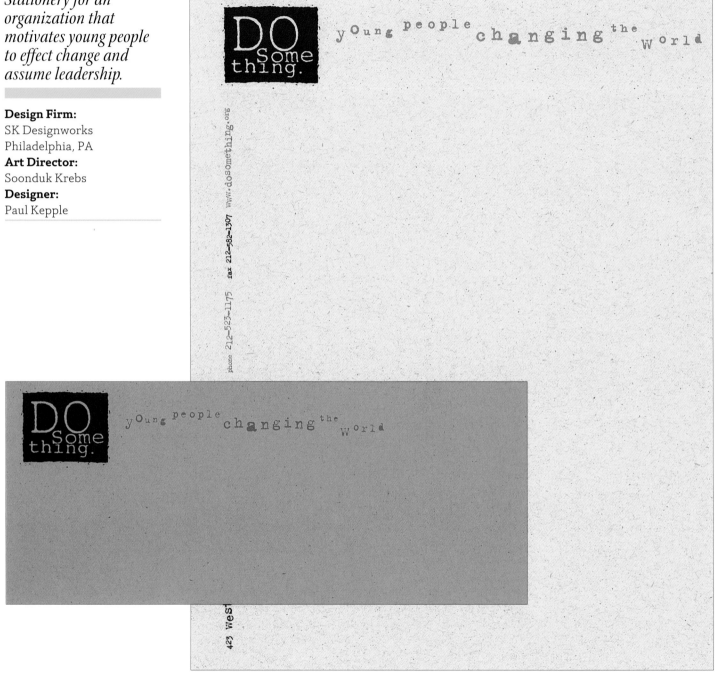

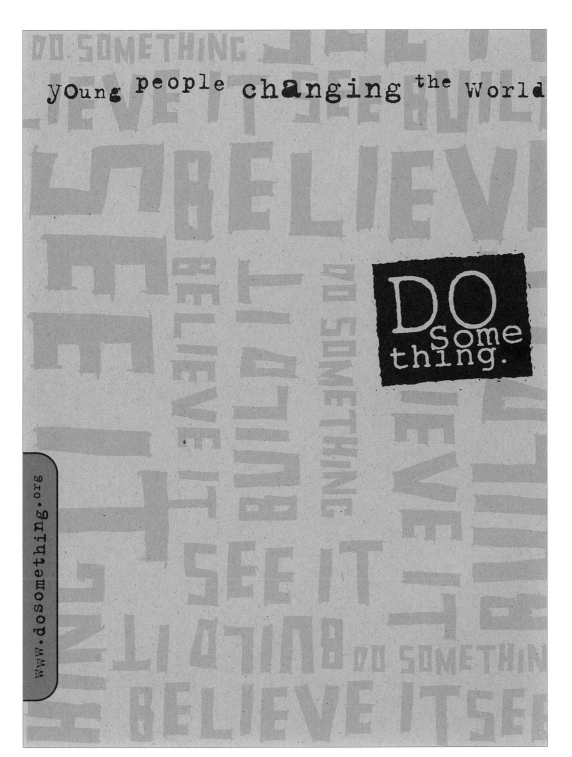

Stationery for the celebration of New York City's Centennial (1898-1998).

Design Firm:
Pentagram
New York, NY
Art Director:
Woody Pirtle
Designers:
Sha-mayne Chan,
Lloyd Rodrigues

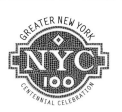

Tania Tiburcio
Deputy Director,
Programs and Marketing

JANUARY-DECEMBER 1998

NEW YORK CITY 100
170 Central Park West
New York, NY 10024-5194
Tel 212-877-6326
Fax 212-877-6343

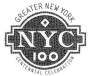

JANUARY DECEMBER 1998

NEW YORK CITY 100
170 Central Park West
New York, NY 10024-5194
Tel 212-579-8726
Fax 212-877-6343

Design Firms

Clients are generally appreciative when a designer gives their stationery the personal touch. It makes them feel (and look) special. But while the average client likes to feel more than average, design firms' desire to stand out from the crowd is all-consuming. They're competing directly with a wilderness of other designers, making the concept of "personal touch" an absolute necessity. That concept can apply in a number of different ways, but ultimately it means that potential clients, on receiving a letter or business card, will be impressed by the warmth and the originality of the communication before them. And in the case of a business card, this reaction should have a side effect: They should feel the urge to keep the card. As designer Tedd Asbille puts it, "Most cards are misplaced and lost; but if you create a strong emotional reaction, people are more likely to remember your work and carry it with them."

Asbille knows whereof he speaks. His striking yellow card, which bears a variety of designs featuring his photograph, tends to create a stir when he hands it out. "People will start showing other people the card and talking about it," he says. "Eventually others ask for one, and when they discover there's more than one design, they want to collect them all." The unusual shape and color of Asbille's card helped it get noticed; his photograph appearing both front and back probably factored into its effect as well. Asbille isn't the only designer in this section who realized that nothing gives a card the personal touch like your own, unique visage peering from the paper. Matt Cordell and David Eller of Soul Visual Communications pushed this approach to its natural conclusion, turning their business card into a photo I.D. Response, predictably, was excellent. "I was actually recognized in a restaurant by someone who had received the card from a mutual friend," states David Eller. "The great thing about the cards is that they get passed around all over the place. People make a point of showing them to friends and associates."

While putting their own faces on their correspondence worked for Asbille and Eller, not all of their peers want to use their physiognomies as promotional materials. Other designers here have found ways of exploiting their idiosyncrasies as client-bait without stepping in front of a camera. Illustrator David Klug's letterhead and business card (designed by Penni Joyce at Red House Communications) bear the image of his dog, Jack, who "keeps him company at his home office." Delessert + Marshall's self-promotional stationery takes a subtle approach to conveying interesting information about the firm. To represent the fact that the studio does international work, and that the partners are European and American, respectively, two rulers appear on edges of the stationery—one in centimeters and one in inches.

The individual attributes described above are definitely appealing, but it could be argued that they have little to do with the actual business of design. Two firms here tackled that aspect of things with stationery that gives their design staffs a chance to shine. Oddly, both of these firms are involved in film as well as graphic design. Principal and art director Scott Colthorp at Atmosphere Pictures describes his company's business cards as follows: "Each employee creates his or her own icon from which a rubber stamp is created. Everyone 'manufactures' his or her own card, which provides for individual expression." The paper of the stationery also features a rubber stamp of the firm's main icon, a dirigible, as well as a drawing of same. Andy Mueller and John Fuller at Ohio Girl Film + Design also turned their cards into a means of displaying designers' talents. "Whereas the letterhead, envelope, mailing labels and the informational side of the business card is the same for everyone," states Mueller, "each individual at the studio received a unique back side of the card. They work like mini-portfolios." Now, that's a personal touch!

SALLY J. WAGNER INC.

Design Firm:
Sally J. Wagner Inc.
Minneapolis, MN
Art Director:
Sally J. Wagner
Designer:
Sally J. Wagner
Illustrator:
Sally J. Wagner

art direction

art

direction

Sally J. Wagner, Inc.
302C Textile Building
119 North 4th Street
Minneapolis, MN 55401
Phone 612 332-1700
Fax 612 332-7749
salpal555@aol.com

Sally J. Wagner, Inc.
302C Textile Building
119 North 4th Street
Minneapolis, MN 55401
Phone 612 332-1700
Fax 612 332-7749
salpal555@aol.com

Design Firm:
bit.Nbydesign
Arlington, VA
Designer:
Todd Gardner

design

illustration

animation

nopreservatives

todd**gardner**

1804queens lane
suite**206**arlington
VA

t/fx 7 **525**
0
3 **7479**

22201

e toddaog@aol.com

bit.Nbydesign

Design Firm:
James Robie Design
Associates
Los Angeles, CA
Design Director:
Wayne Fujita
Designer:
Karen Nakatani

JAMES ROBIE DESIGN ASSOCIATES

JAMES ROBIE DESIGN ASSOCIATES

152-½ N. La Brea Avenue
Los Angeles, California
90036-2912

	PHONE	FAX	E.MAIL	WEB SITE
152-½ N. La Brea Avenue Los Angeles, California 90036-2912	323.939.7370	323.937.9728	jrda@robie.com	www.robie.com

JAMES ROBIE DESIGN ASSOCIATES

CAROLE FOSTER
PROJECT DIRECTOR

152-½ N. La Brea Avenue
Los Angeles, California
90036-2912

PHONE
323.939.7370 Ext.14
FAX
323.937.9728
E-MAIL
cfoster@robie.com
WEB SITE
www.robie.com

JAMES ROBIE DESIGN ASSOCIATES

152-½ N. La Brea Avenue
Los Angeles, California
90036-2912

Design Firm:
Jerilyn Fuhrer Graphic
Design
Stony Brook, NY
Designer:
Jerilyn Fuhrer

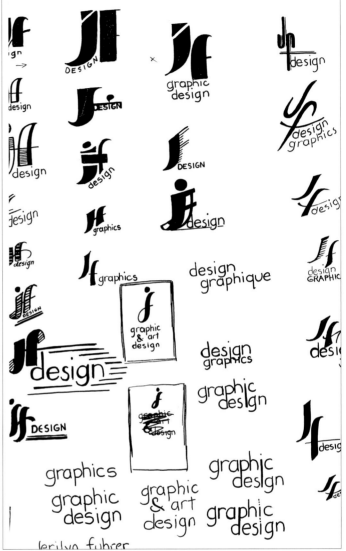

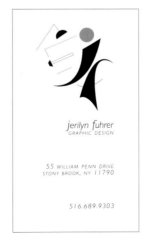

jerilyn fuhrer
GRAPHIC DESIGN

55 WILLIAM PENN DRIVE
STONY BROOK, NY 11790

516.689.9303

Design Firm:
Costello Communications
Chicago, IL
Art Director:
James Costello
Designer:
James Costello

COSTELLO COMMUNICATIONS
1415 NORTH DAYTON, SUITE 301
CHICAGO, ILLINOIS 60622
312.255.9825 TELEPHONE
312.255.0950 FAX

Design Firm:
McGaughy Design
Falls Church, VA
President:
Malcolm McGaughy

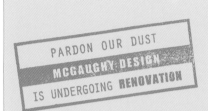

WE CAN STILL BE REACHED AT:
3706-A STEPPES COURT
FALLS CHURCH, VA 22041
703·578·1375 / FAX 578·9658
MCGDESIGN@AOL.COM

PARDON OUR DUST
MCGAUGHY DESIGN
IS UNDERGOING RENOVATION
WE CAN STILL BE REACHED AT:
3706-A STEPPES COURT
FALLS CHURCH, VA 22041
703·578·1375 / FAX 578·9658
MCGDESIGN@AOL.COM

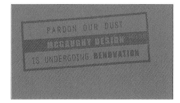

Design Firm:
Mortensen Design
Mountain View, CA
Art Director:
Gordon Mortensen
Designers:
Gordon Mortensen,
Diana L. Kauzlarich
Production:
Diana L. Kauzlarich

Mortensen Design 416 Bush Street Mountain View, CA 94041-2106 P 650 988 0946 F 650 988 0926

Gordon Mortensen
Owner/Principal Designer
Mortensen Design
416 Bush Street
Mountain View, CA 94041
Email: gmort@mortdes.com

P 650 988 0946 • F 650 988 0926

TEDD ASBILLE DESIGN

Design Firm:
Tedd Asbille Design
Chicago, IL
Art Director:
Tedd Asbille
Designer:
Tedd Asbille
Photographer:
Al Guerrero
Makeup:
Ella Yakir

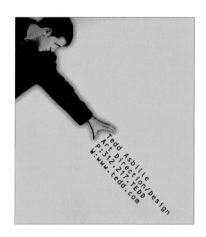

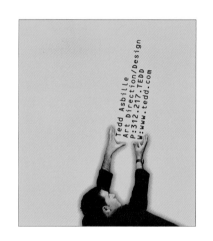

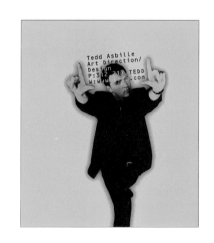

Design Firm:
Landry Design Associates
Andover, MA
Art Director:
Lynn Landry
Designer:
Jeff Venier
Illustrator:
Jeff Venier

Landry Design

LANDRY DESIGN

Design Firm:
Red House Communications, Inc.
McKeesport, PA
Designer:
Penni Joyce
Illustrator:
Dave Klug

DAVE KLUG

2304 JAMES STREET . MCKEESPORT PA 15132

DAVE KLUG

2304 JAMES STREET . MCKEESPORT PA 15132
412.754.KLUG (5584) . FAX 412.754.9881

INVOICE

DATE

DAVID KLUG
2304 JAMES STREET . MCKEESPORT PA 15132
412.754.5584
S.S.# 159.60.0130

CUSTOMER'S ORDER NO.

SOLD TO: SHIPPED TO:

DATE SHIPPED SHIPPED VIA

QTY. ORDERED	QTY. SHIPPED	DESCRIPTION	PRICE	PER	AMOUNT

PAYMENT IS DUE WITHIN THIRTY (30) DAYS OF RECEIPT OF INVOICE

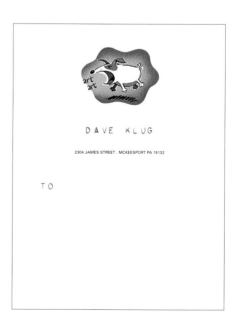

DAVE KLUG

2304 JAMES STREET . MCKEESPORT PA 15132

T O

Design Firm:
Coyne Maur Bane Design
Folsom, CA
President:
Paul Coyne
Vice President of Marketing:
Jeff Bane
C.F.O.:
Brad Maur

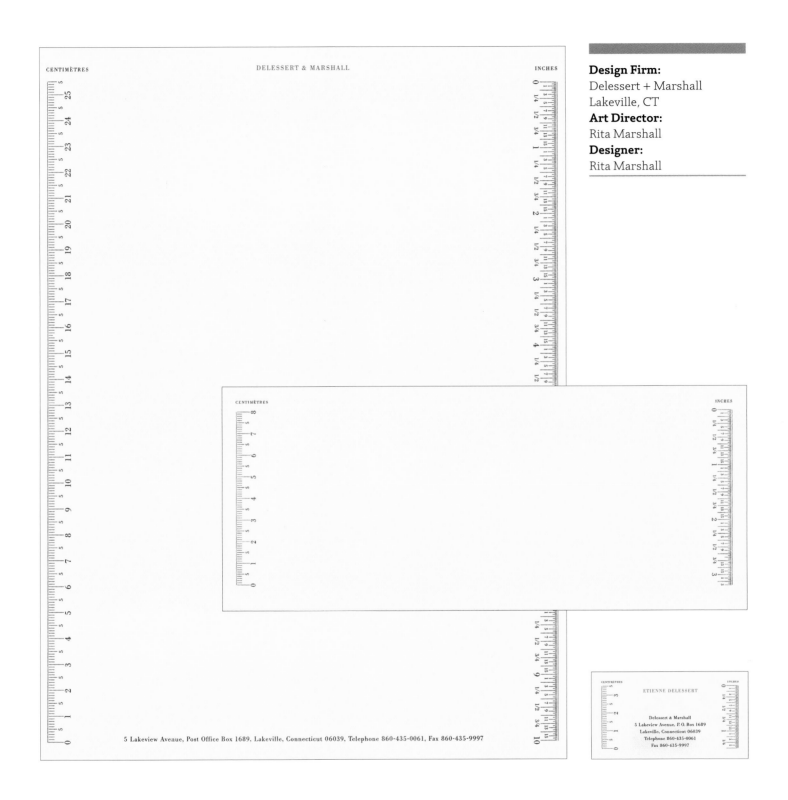

Design Firm:
Delessert + Marshall
Lakeville, CT
Art Director:
Rita Marshall
Designer:
Rita Marshall

Design Firm:
Fuszion Art + Design
Alexandria, VA
Art Director:
Richard Lee Heffner
Designers:
Richard Lee Heffner,
Anthony Fletcher,
Michael Pfister

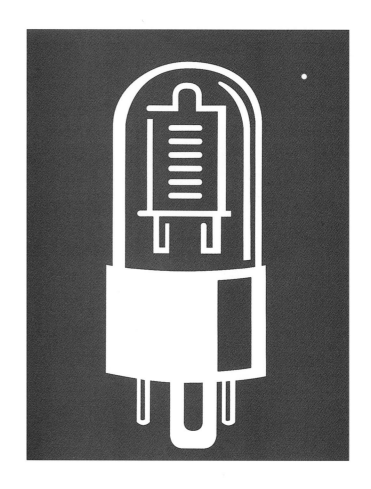

Design Firm:
Soul Visual Communications
Charlotte, NC
Art Directors:
Matt Cordell,
David Eller
Designer:
Matt Cordell

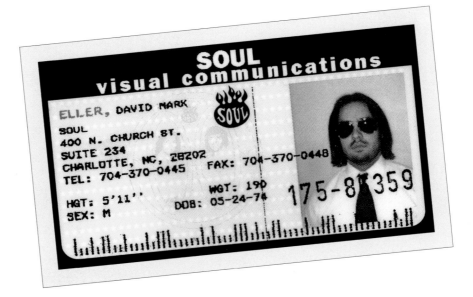

STEVEN MORRIS DESIGN, INC.

Design Firm:
Steven Morris Design, Inc.
San Diego, CA
Art Director:
Steven Morris
Designers:
Steven Morris,
Cynthia Jacobsen

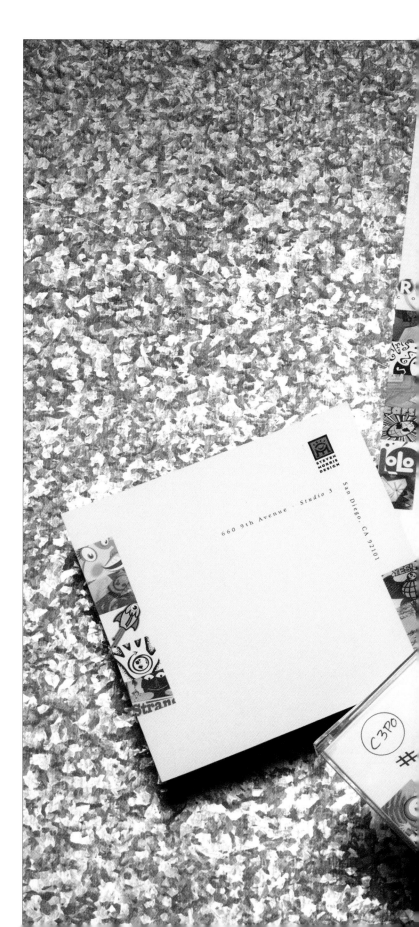

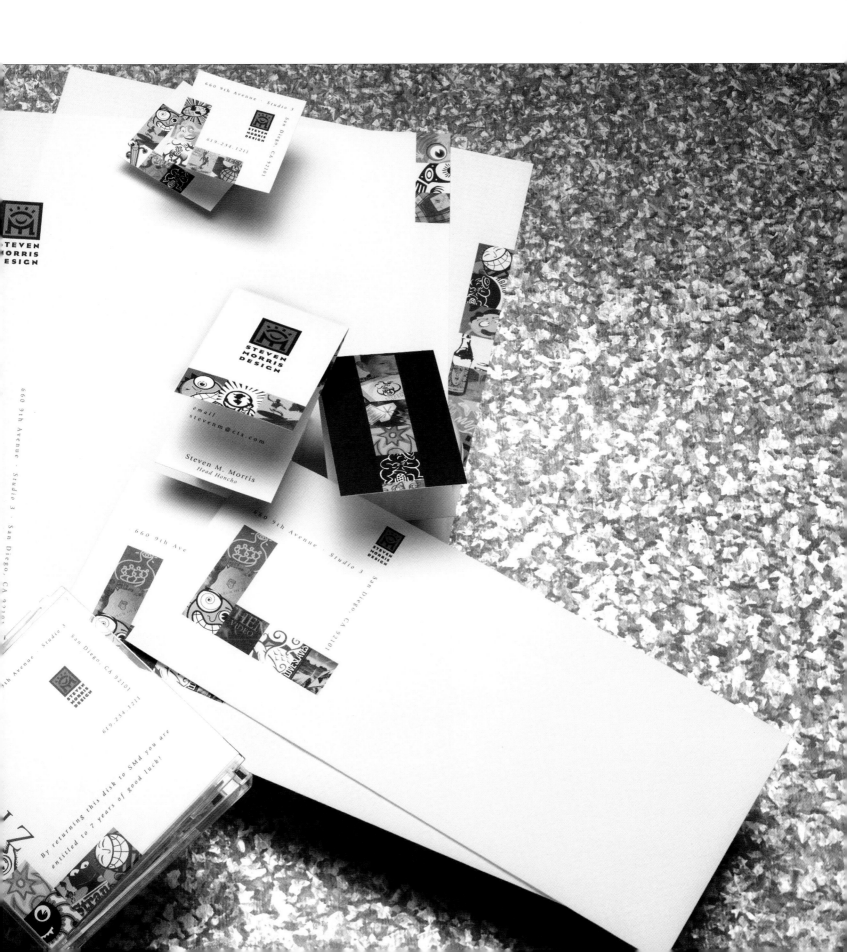

Design Firm:
Gina Palmer Illustration
Rhinebeck, NY
Illustrator:
Gina Palmer

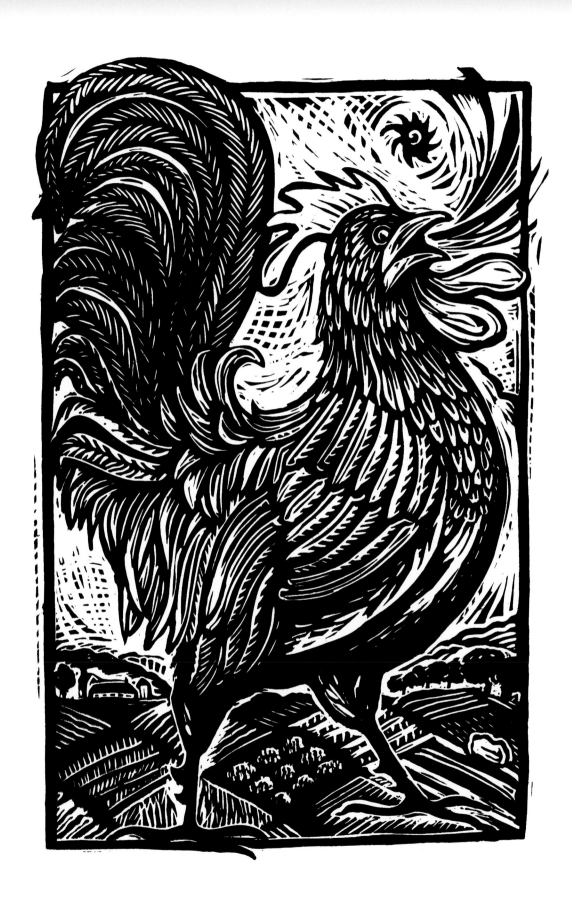

Design Firm:
Direction Design
Los Angeles, CA
Art Directors:
Anja Mueller,
Teresa E. Lopez
Designer:
Anja Mueller

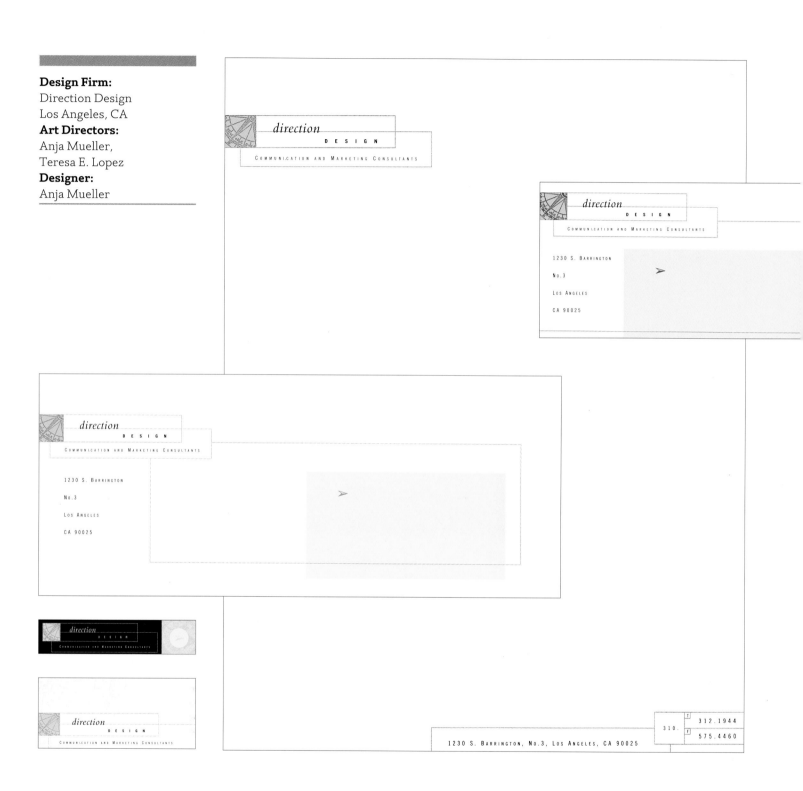

Design Firm:
Ohio Girl Film + Design
Chicago, IL
Art Directors:
Andy Mueller,
John Fuller
Designers:
Andy Mueller,
John Fuller

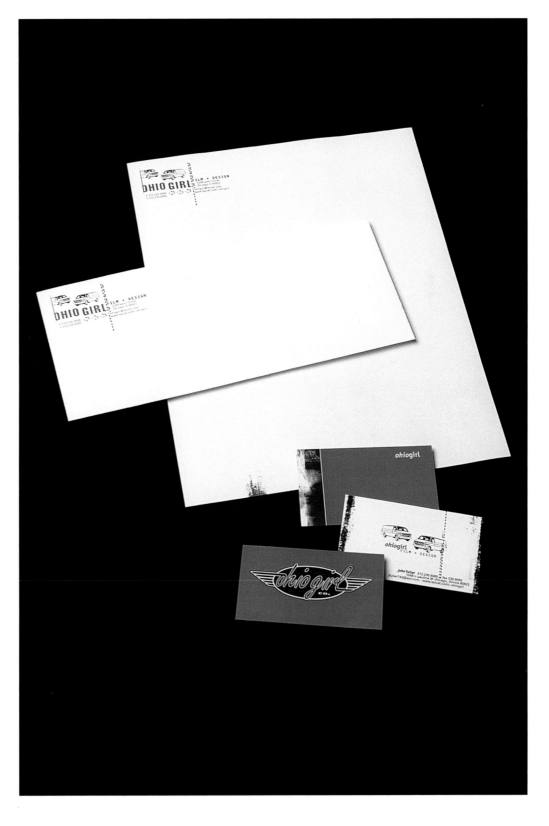

Design Firm:
Atmosphere Pictures
Knoxville, TN
Principal:
Scott Colthorp
Art Director:
Scott Colthorp
Designer:
Craig Colthorp
Illustrator:
Danny Wilson

Caitlin Dover, Project Manager
PRINT's Best Logos & Symbols 6
RC PUBLICATIONS
104 Fifth Avenue, 19th Floor
New York, NY 10011

07.12.99

atmosphere pictures
130 w jackson
suite 202
knoxville tn 37902
p 423.540.3710
f 423.540.8640
www.atmospherepictures.com

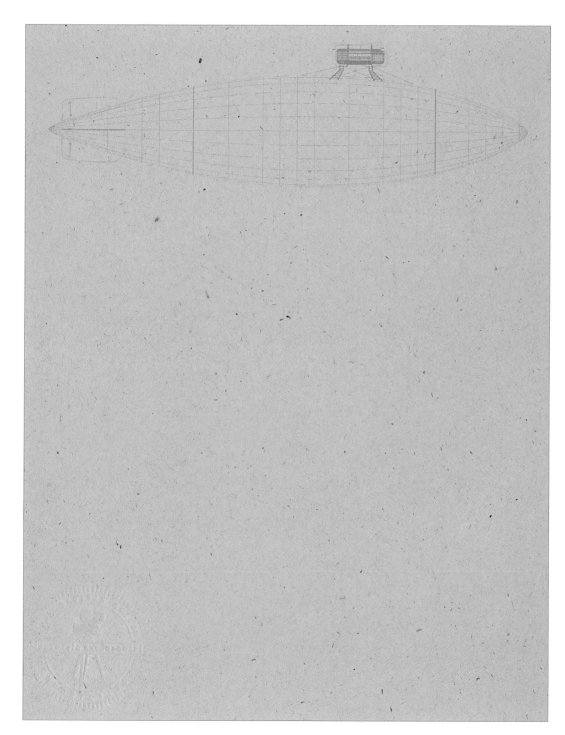

JIM PHILLIPS
SR. DESIGN GUY

atmosphere pictures
130 w jackson
suite 202
knoxville tn 37902
p 423.540.8710
f 423.540.8640
www.atmospherepictures.com

JEFF WOODS
№ 3102659

atmosphere pictures
130 w jackson
suite 202
knoxville tn 37902
p 423.540.8710
f 423.540.8640
www.atmospherepictures.com

JENNIFER FARIS
525x3625

atmosphere pictures
130 w jackson
suite 202
knoxville tn 37902
p 423.540.8710
f 423.540.8640
www.atmospherepictures.com

CRAIG CULTHORP
609x7367

atmosphere pictures
130 w jackson
suite 202
knoxville tn 37902
p 423.540.8710
f 423.540.8640
www.atmospherepictures.com

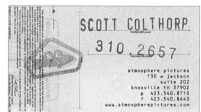

SCOTT COLTHORP
310.2657

atmosphere pictures
130 w jackson
suite 202
knoxville tn 37902
p 423.540.8710
f 423.540.8640
www.atmospherepictures.com

Design Firm:
Nestor Stermole Visual
Communications Group
New York, NY
Creative Directors:
Rick Stermole,
Okey Nestor
Designer:
Robert Wirth

NESTOR.STERMOLE VISUAL COMMUNICATIONS GROUP
19 WEST 21ST STREET NO.602 NEW YORK NEW YORK 10010
T>212 229-9377 F>212 229-9422 E>NS@INTERPORT.NET

NESTOR.STERMOLE VISUAL COMMUNICATIONS GROUP
19 WEST 21ST STREET NO.602 NEW YORK NEW YORK 10010

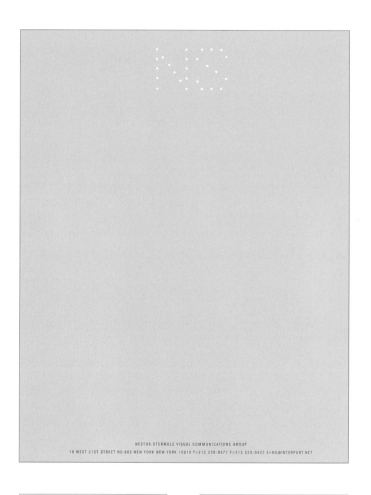

WILLIAM MORRISEY

NESTOR.STERMOLE VISUAL COMMUNICATIONS GROUP
19 WEST 21ST STREET NO.602 NEW YORK NEW YORK 10010
T>212 229-9377 F>212 229-9422 E>NS@INTERPORT.NET

IAN T. CHASE

NESTOR.STERMOLE VISUAL COMMUNICATIONS GROUP
19 WEST 21ST STREET NO.602 NEW YORK NEW YORK 10010
T>212 229-9377 F>212 229-9422 E>NS@INTERPORT.NET

OKEY NESTOR

NESTOR.STERMOLE VISUAL COMMUNICATIONS GROUP
19 WEST 21ST STREET NO.602 NEW YORK NEW YORK 10010
212 229-9377 F>229-9422 E>OKEY@NESTOR-STERMOLE.COM

RICK STERMOLE

NESTOR.STERMOLE VISUAL COMMUNICATIONS GROUP
19 WEST 21ST STREET NO.602 NEW YORK NEW YORK 10010
212 229-9377 F>229-9422 E>RICK@NESTOR-STERMOLE.COM

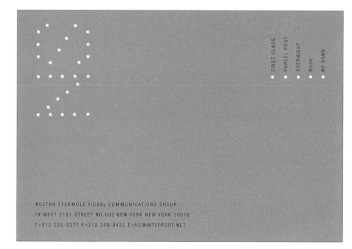

Agency:
Carmichael Lynch Thorburn
Minneapolis, MN
Creative Director:
Bill Thorburn
Designer:
Chad Hagen
Illustrators:
Chad Hagen,
David Schrimpf

LETTER] MARK]

Carmichael Lynch Thorburn
800 Hennepin Avenue
Minneapolis MN 55403

Ph 612 334 6000
Fx 612 334 1434

COOL

RESOURCE

Return Carmichael Lynch Thorburn
800 Hennepin Avenue
Minneapolis MN 55403

c/o

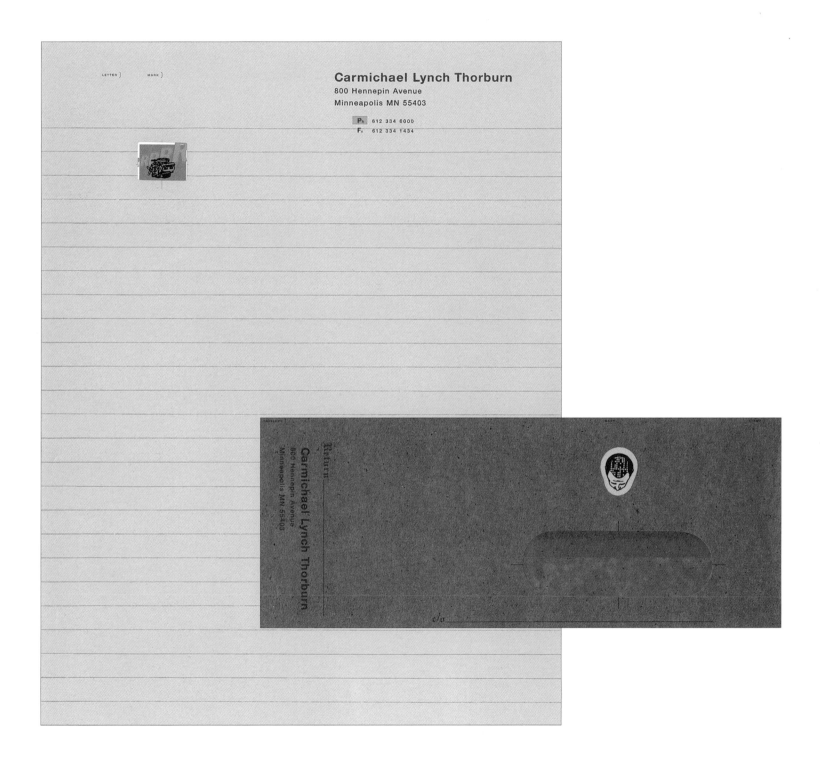

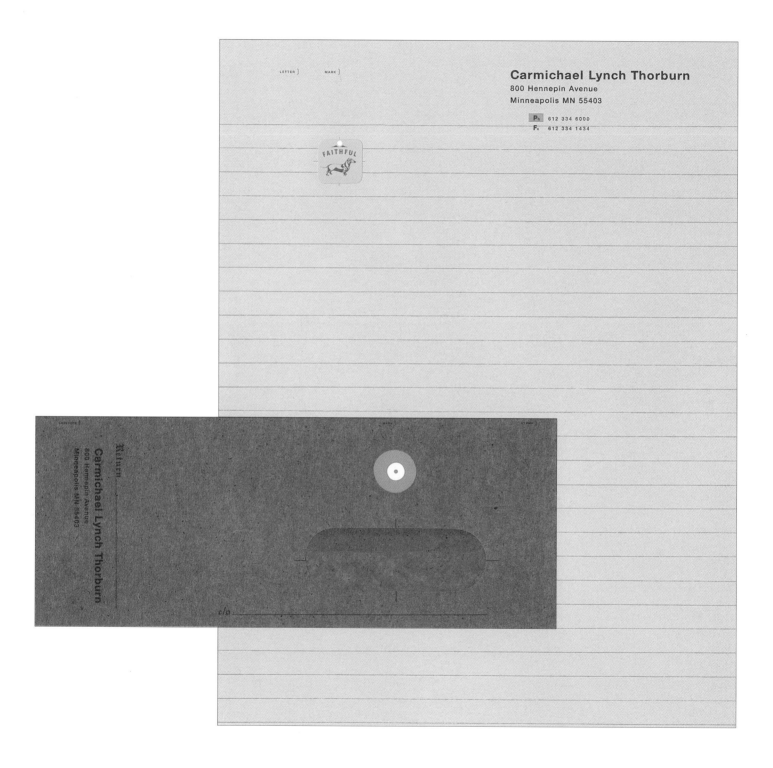

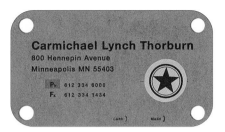

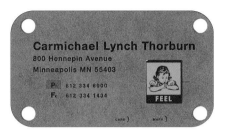

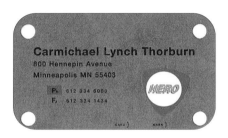

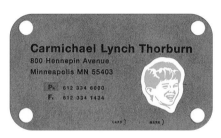

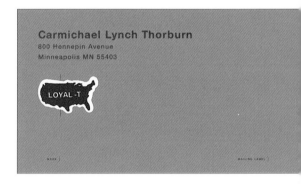

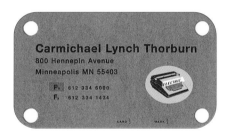

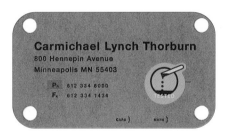

Design Firm:
Anabliss Graphic/Design
Englewood, CO
Owner:
Matt Coffman
Designer:
Matt Coffman
"Inspiration":
Brian Goedert,
Kristen Fering

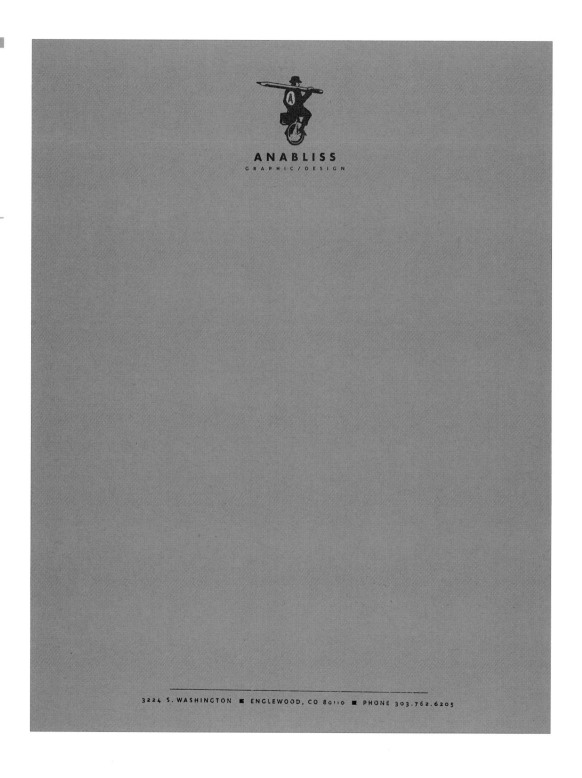

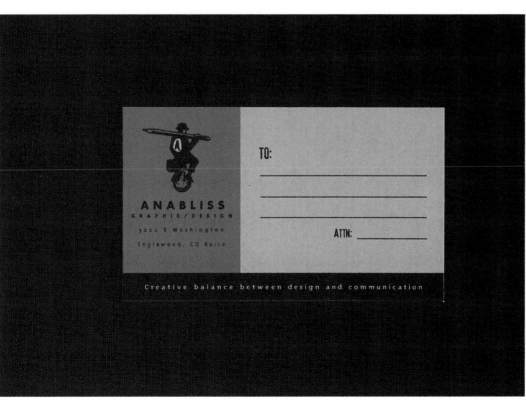

Design Firm:
BAH! Design
Austin, TX
Creative Directors:
Neely Ashmun,
Scott Herron
Designer:
Scott Herron

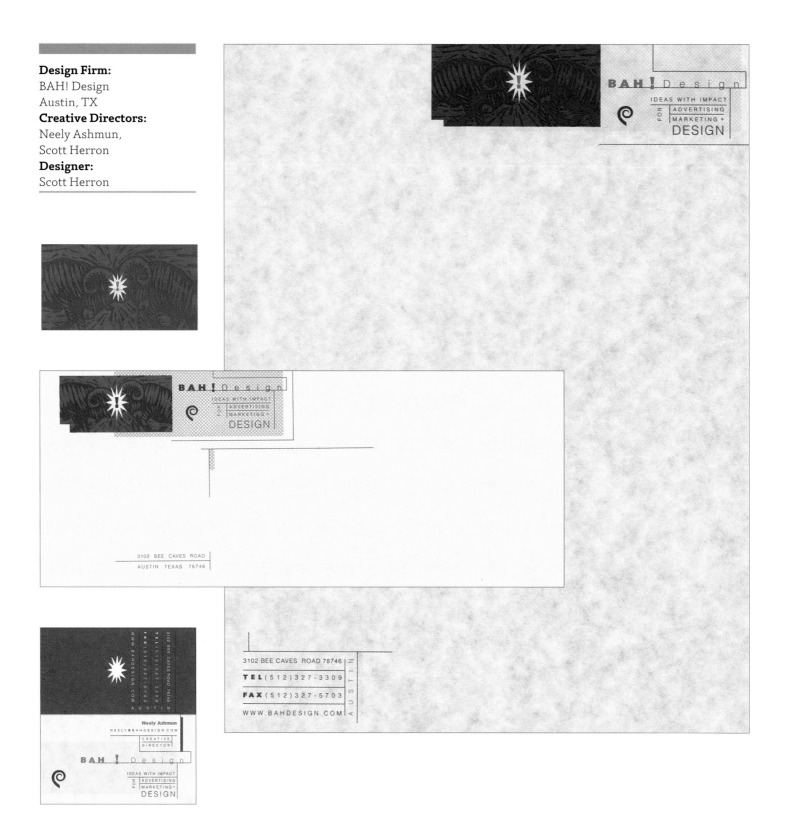

LEAP DESIGN

Design Firm:
Leap Design
Durham, NC
Designer:
Laurie Goldman

Design Firm:
Hornall Anderson Design
Works
Seattle, WA
Art Director:
Jack Anderson
Designers:
Jack Anderson,
David Bates
Illustrator:
David Bates

1008
Western Ave
Suite 600
Seattle, WA
98104

1008
Western Ave
Suite 600
Seattle, WA
98104

206 467 5800
FAX 467 6411
www.hadw.com

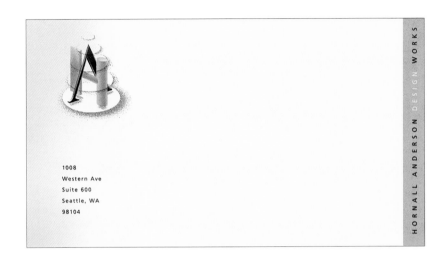

Design Firm:
K2 Design
Rochester, NY
Designer:
Kurt Ketchum

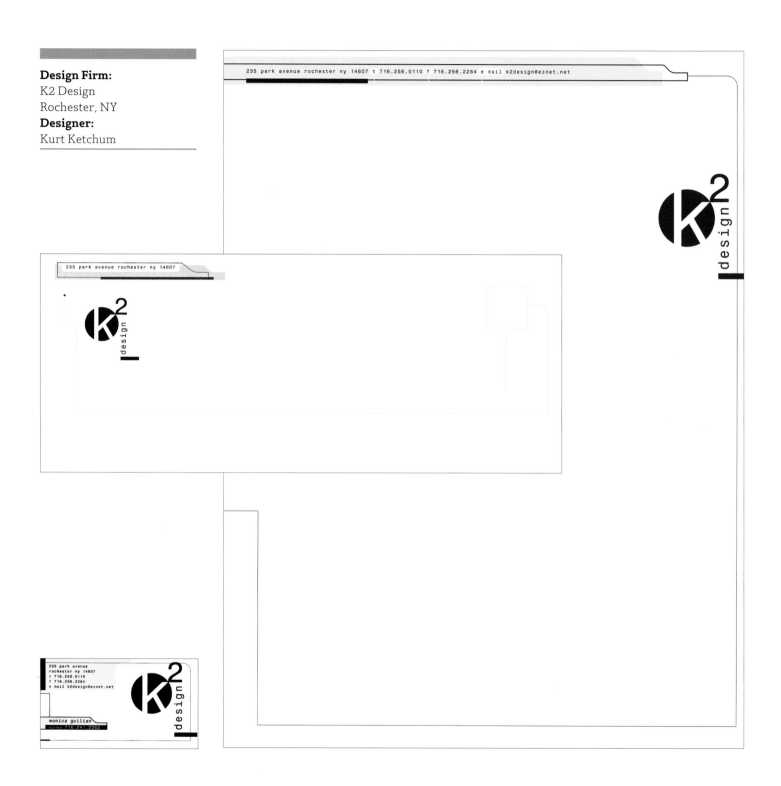

235 park avenue rochester ny 14607 t 716.256.0110 f 716.256.2284 e mail k2design@eznet.net

235 park avenue rochester ny 14607

235 park avenue
rochester ny 14607
t 716.256.0110
f 716.256.2284
e mail k2design@eznet.net

monica guilian
direct 716.241.2362

Design Firm:
Chris A. Schott Illustration
and Design Studio
St. Louis, MO
Designer:
Chris Schott

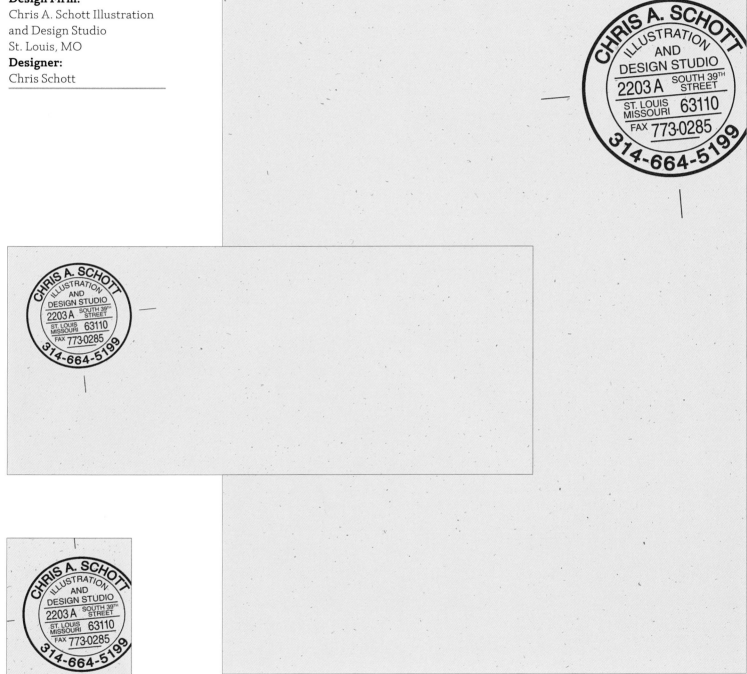

Design Firm:
Renee Rech Design
Norfolk, VA
Art Director:
Renee Rech
Designer:
Renee Rech

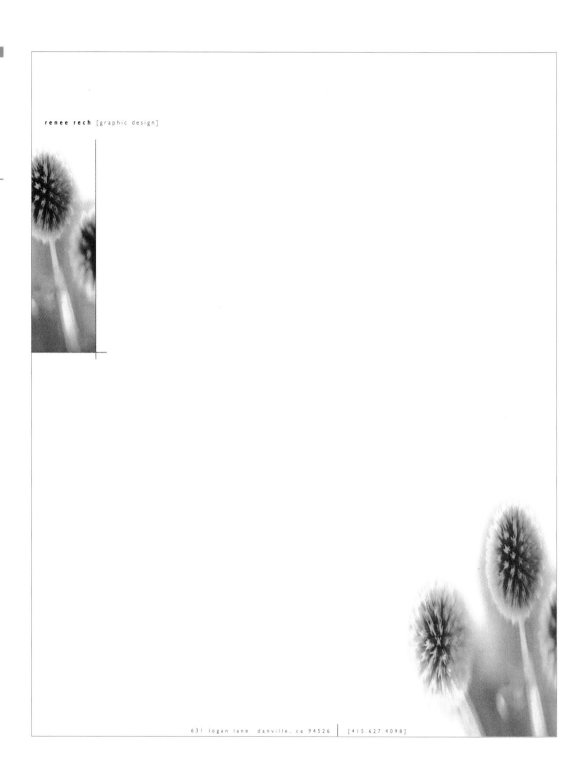

renee rech [graphic design]

631 logan lane danville, ca 94526 | [415.627.4098]

renee rech [graphic design]

631 logan lane danville ca 94526 [415.627.4098]

i like to find
what's not
found at once,

but lies within
something of another nature
in repose,

distinct.

[Denise Levertov]

renee rech [graphic design]

631 logan lane
danville ca 94526

[415.627.4098]

how solid
are the

walls
that
define us?

Design Firm:
Murder by Design
San Francisco, CA
Art Director:
Peter Kowaleszyn
Designer:
Peter Kowaleszyn
Photographer:
Peter Kowaleszyn

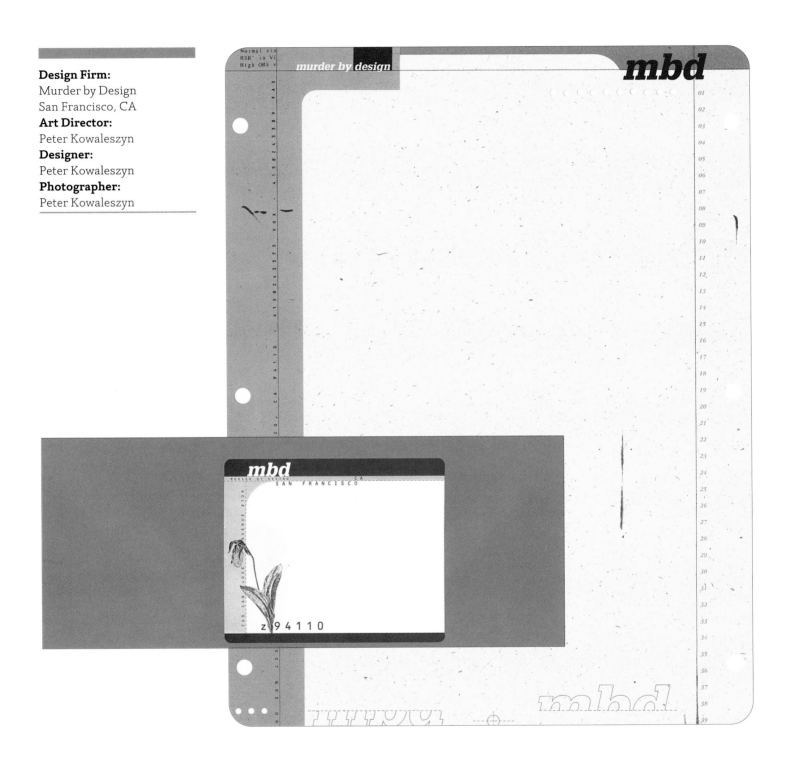

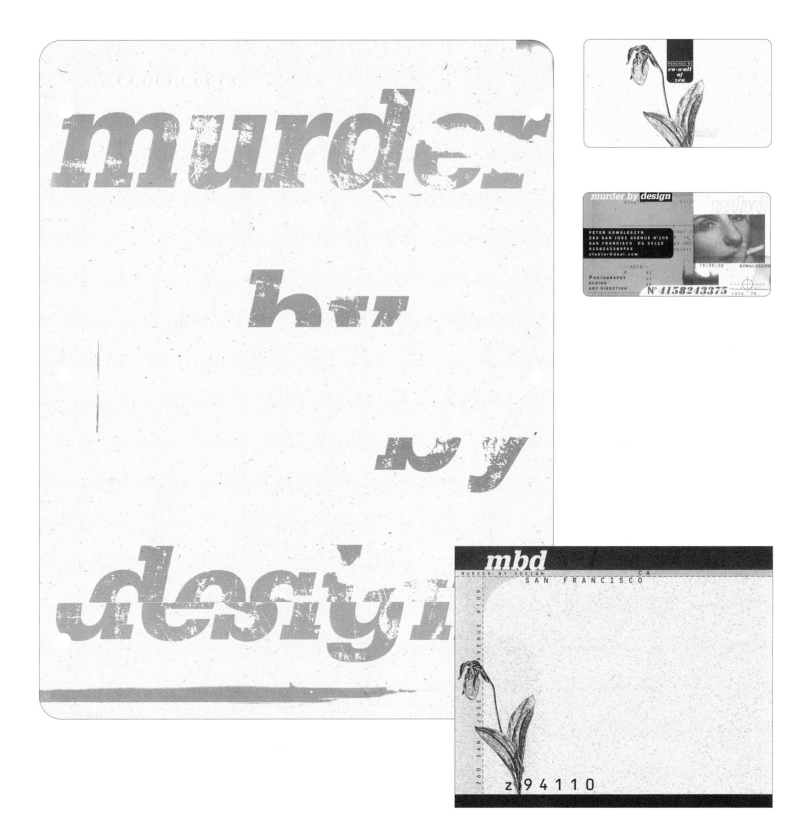

BRAND A STUDIO

Design Firm:
Brand A Studio
San Francisco, CA
Art Director:
Guthrie Dolin
Designers:
Guthrie Dolin,
Julie Cristello

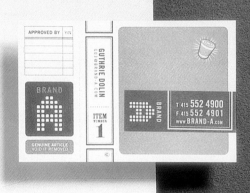

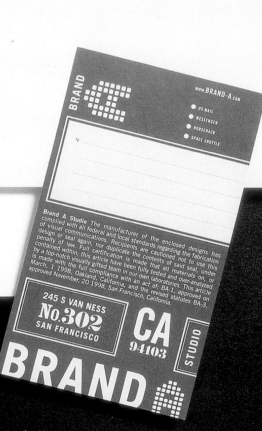

Design Firm:
Kevin Carlini
Advertising Artist
Canfield, OH
Designer:
Kevin Carlini

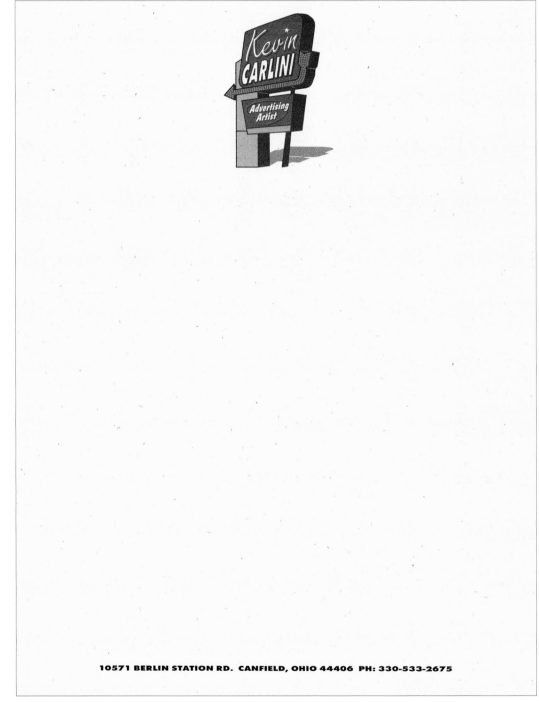

10571 BERLIN STATION RD. CANFIELD, OHIO 44406 PH: 330-533-2675

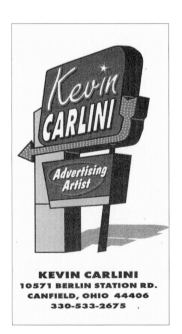

KEVIN CARLINI
10571 BERLIN STATION RD.
CANFIELD, OHIO 44406
330-533-2675

Design Firm:
Hothouse Design +
Advertising
Boulder, CO
Creative Director:
Jing Tsong
Designer:
Kurt Simmerman

Design Firm:
Crow Studios
Scottsdale, AZ
President/Owner:
R. Scott Havice

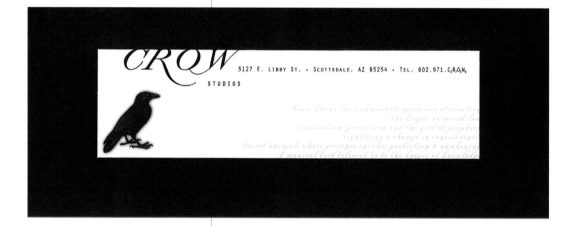

CRQW
STUDIOS

Crow knows the unknowable mysteries of
QUALITY, CREATIVITY, AND PROFESSIONALISM he keeper of sa
...initiation, protection and the gift of p
...signifying a change in conse
Sacred animals whose presence invokes protection & aw
A magical bird believed to be the keeper of k
5127 E. LIBBY ST. • SCOTTSDALE, AZ
TEL, 602.971.C₂R₇O₆W₉ • FAX, 602.97

CRQW
STUDIOS

5127 E. LIBBY ST
SCOTTSDALE, AZ 85254
TEL, 602.971.C.R.O.W,
FAX, 602.971.2770
E-MAIL: CROW@NETVALUE.NET

Quality, Creativity and Professionalism

R. Scott Harvie
PRESIDENT

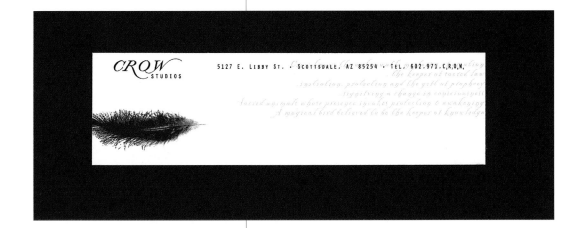

Design Firm:
Lure Design
Orlando, FL
Designers:
Jeff Matz,
Cheryl Frey,
Paul Mastriani
Photographer:
Allan Maxwell
Writer:
Jane Harrison

JEFF MATZ
CHERYL FREY
PAUL MASTRIANI

LURE DESIGN INCORPORATED

POST OFFICE BOX 531144
ORLANDO FLORIDA 32853
TELEPHONE 407 896 1906
FACSIMILE 407 896 1722

LURE DESIGN INCORPORATED

POST OFFICE BOX 531144
ORLANDO FLORIDA 32853

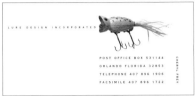

LURE DESIGN INCORPORATED

POST OFFICE BOX 531144
ORLANDO FLORIDA 32853
TELEPHONE 407 896 1906
FACSIMILE 407 896 1722

CHERYL FREY

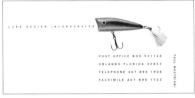

LURE DESIGN INCORPORATED

POST OFFICE BOX 531144
ORLANDO FLORIDA 32853
TELEPHONE 407 896 1906
FACSIMILE 407 896 1722

PAUL MASTRIANI

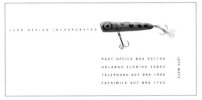

LURE DESIGN INCORPORATED

POST OFFICE BOX 531144
ORLANDO FLORIDA 32853
TELEPHONE 407 896 1906
FACSIMILE 407 896 1722

JEFF MATZ

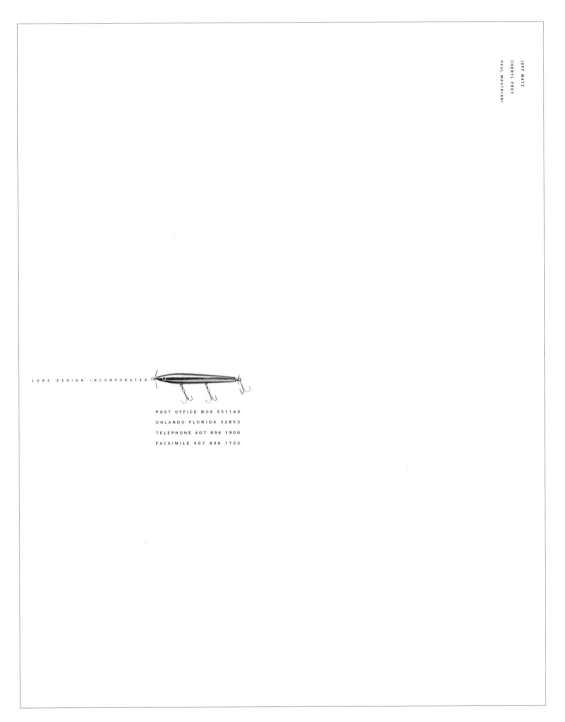

JEFF MATZ
CHERYL FREY
PAUL MASTRIANI

LURE DESIGN INCORPORATED

POST OFFICE BOX 531144
ORLANDO FLORIDA 32853
TELEPHONE 407 896 1906
FACSIMILE 407 896 1722

Design Firm:
SooHoo Designers
Torrance, CA
Art Directors:
Patrick SooHoo
Kathy Hirata
Designers:
Daniel Ko,
Karen Leonard,
Cindy Hahn,
Dan Wu,
Leo Terrazas

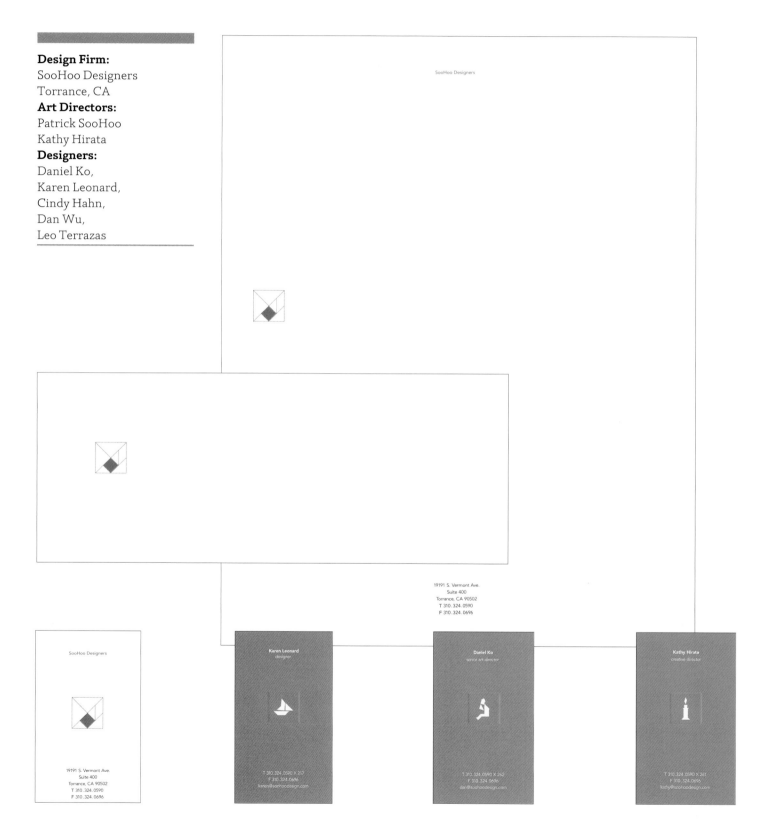

SooHoo Designers

19191 S. Vermont Ave.
Suite 400
Torrance, CA 90502
T 310.324.0590
F 310.324.0696

SooHoo Designers

19191 S. Vermont Ave.
Suite 400
Torrance, CA 90502
T 310.324.0590
F 310.324.0696

Karen Leonard
designer

T 310.324.0590 X 217
F 310.324.0696
karen@soohoodesign.com

Daniel Ko
senior art director

T 310.324.0590 X 262
F 310.324.0696
dan@soohoodesign.com

Kathy Hirata
creative director

T 310.324.0590 X 281
F 310.324.0696
kathy@soohoodesign.com

SooHoo Designers

19191 S. Vermont Ave.
Suite 400
Torrance, CA 90502

SooHoo Designers

19191 S. Vermont Ave.
Suite 400
Torrance, CA 90502

Dan Wu
designer

T 310.324.0590 X 258
F 310.324.0696
dw@soohoodesign.com

Will Riley
account executive

T 310.324.0590 X 251
F 310.324.0696
will@soohoodesign.com

Patrick SooHoo
president

T 310.324.0590 X 263
F 310.324.0696
patrick@soohoodesign.com

Pam H.Healy
administrator

T 310.324.0590 X 211
F 310.324.0696
pam@soohoodesign.com

Index